CRANLEIGH

THROUGH TIME

Michael Miller

AMBERLEY PUBLISHING

First published 2013

Amberley Publishing
The Hill, Stroud
Gloucestershire, GL5 4EP

www.amberley-books.com

Copyright © Michael Miller, 2013

The right of Michael Miller to be identified as the
Author of this work has been asserted in accordance
with the Copyrights, Designs and Patents Act 1988.

ISBN 978 1 4456 0549 4

British Library Cataloguing in Publication Data.
A catalogue record for this book is available from
the British Library.

Typeset in 9.5pt on 12pt Celeste.
Typesetting by Amberley Publishing.
Printed in the UK.

Introduction

The history of Cranleigh has been well documented to the extent that the reader may question if there is more to be said. However, new discoveries are now available to researchers, and notable amongst these are the use of the internet and dendrochronology to determine the age of a building to the nearest year.

Old photographs and postcards, once thought to have been lost forever, are still coming to light through bequests and auctions, and enhancements to scanning and printing methods now make these available to interested readers. In compiling this publication the author has attempted to use as much original material as possible, but in the interests of completeness some illustrations will have inevitably been seen before. Many of these pictures now form the basis of an archive of the Cranleigh History Society but the majority, particularly the postcards, are the personal collection of the author put together from trawling through boxes at fairs and browsing the ever-increasing websites on the internet.

There is more than one approach to writing a retrospective of village life and in this case I have attempted to take the reader on a walk around the main landmarks with a view from former times. At the same time one recognises that history is not just about the changing landscape but the people that lived there and especially those that have influenced change.

In Cranleigh's case three people can take particular credit for transforming the village from the few hundred or so artisans and farmworkers, once unkindly described as 'rustics', into the thriving, modern community of today. John Henry Sapte took up residence as our rector, under the patronage of his father Francis, in 1846. This was a time of great change nationally and Sapte was influential in setting up the National School in 1847, Cranleigh School in 1865, and he also commissioned local architect Henry Woodyer to make improvements to the church and build a new rectory befitting his newfound status. Sapte's influence on the village community spanned sixty years until his death in 1906, by which time he had been made Archdeacon of Surrey.

Sapte, along with local surgeon Albert Napper, set up the first Cottage Hospital in the country, which became a model for others nationwide. The old cottage remains as one of the finest buildings of its type in Surrey, although it no longer provides a medical service and its future use remains indeterminate. Albert's son Arthur carried on the tradition after his father's retirement and made improvements to his home at Broadoak.

Stephen Rowland came to assist his uncle Henry in his grocery store. After just a few years he was able to set up on his own in Ivy Hall Farm, where he added the frontage still visible today. He was responsible for bringing gas and water to the village as a precursor to developing the New Park estate in the 1890s. New Park Road, Avenue Road and Bridge Road are the realisation of Rowland's vision of tree-lined avenues with substantial buildings of character along each side. A condition of purchase was that a house of certain value had to be built on each plot. In some cases this criterion was met by building large semi-detached houses, but eventually economic pressures prevailed and the Land Company took over with the express purpose of disposing of the remaining plots. Much later Oakdene Estates took over development and built many of the houses in collaboration with Messrs Warren & Sons (builders). These are recognisable by a characteristic 'O' in the soffits of the porches.

The arrival of the railway in 1865 certainly changed the character of the village. It heralded the establishment of Cranleigh School for the sons of middle-class families. With easier access to London the village grew as a commuter area, building trades flourished and new commercial enterprises sprang up. Typical of these were Henry Upperton Knight the photographer, A. Peaks Fancy Bazaar, F. J. Delves Hairdresser and Stationer, and more recently David Mann & Sons, ironmongers and furnishers.

A later key figure in the growth of the village was A. B. Johnston. He purchased much of the land along the Horsham Road and with builders Auchterlonie & Reeves developed many of the houses that still stand today.

Population growth was slow but steady up to the 1960s when Cranleigh was designated an overspill area for Guildford. This coincided with the closing of the railway, the opening of Stocklund Square and the development of the Hitherwood, Summerlands and Parkmead estates.

Cranleigh today has evolved into pleasant living space which strives to meet the requirements of its inhabitants while still retaining its village character.

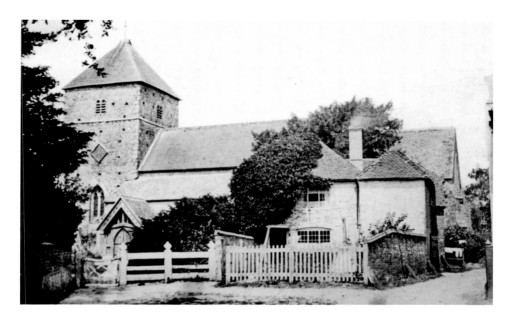

St Nicolas Church

The parish church of St Nicolas dates from the twelfth century and has been at the centre of community life ever since. The tower is later and now houses a peal of eight bells. The building underwent considerable restoration in Victorian times under the supervision of local architect Henry Woodyer. The porch was added at this time and dedicated to Jacob Ellery, the local surgeon. This photograph dates from around 1870 and shows the Maltster's cottage, which was demolished soon afterwards to allow for expansion of the burial ground. Today the church has changed little in external appearance and is a symbol of constancy in a changing world. The cedar tree, brought back as a seedling by Revd Sapte from his honeymoon in the Holy Land, now dominates the churchyard and overshadows the tower.

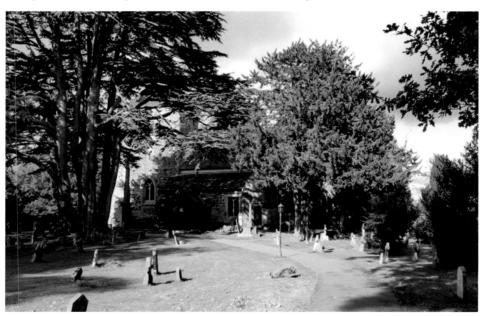

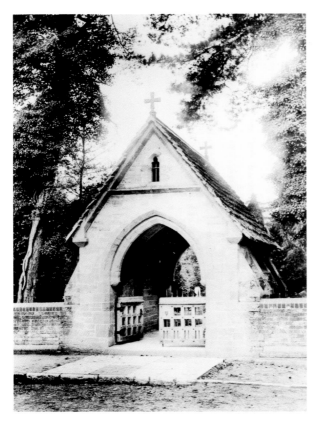

Lychgate

The Lychgate was built in 1880 to the 'Honor of God and in Memory of His Servant John Bradshaw of Knowle' and given by his widow. It is a substantial construction, built of local stone and oak timbers, to a design by local architect, Henry Woodyer. The original construction had wooden gates, which deteriorated and were not replaced.

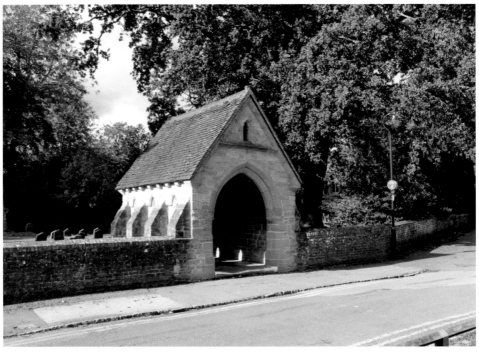

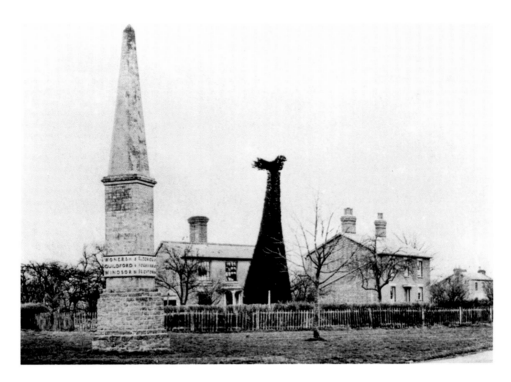

Obelisk

The Obelisk is one of Cranleigh's notable landmarks, although little is known about its origins. The base is built of dressed blocks of Paludina limestone or Sussex marble and contains small shells of ancient crustaceans. The upper portion is of sandstone rendered to a smooth finish. Some contemporary drawings show it topped with a pineapple, but if there ever was one, there is no evidence of it today. It commemorates the opening of the turnpike road in the 1820s and was subscribed by local surgeon Jacob Ellery. The direction indicator plates show Cranleigh to be 31 miles equidistant between Windsor and Brighton and were thought to give comfort to the Prince Regent, later George IV, on his processions between his two palaces. The old yew tree, once carved in the shape of a cockerel, is still there but a shadow of its former self.

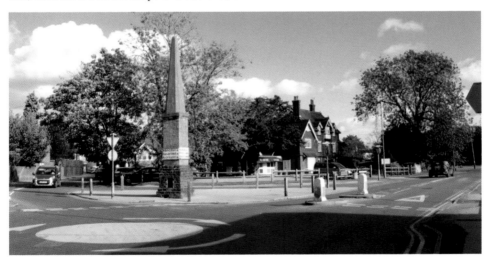

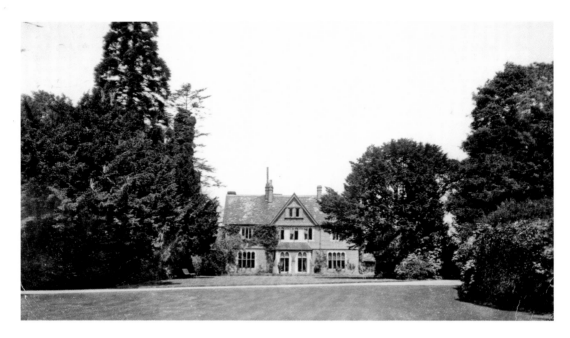

Rectory

The present rectory is at least the fourth to serve this purpose. The picture shows the Victorian building designed by Henry Woodyer with a clear view from the lawn where the current building now stands. Built around 1865 it stands on a moated site, which may have once been the location of an earlier Saxon church. The substantial building displays many architectural features including mullioned lancet windows echoing those in the church.

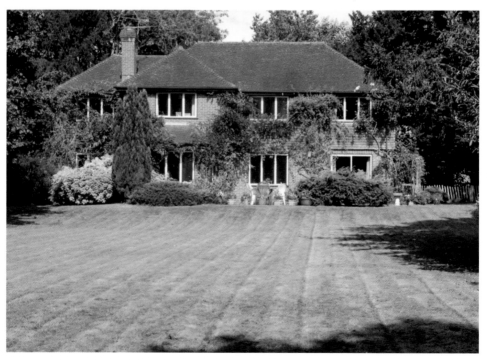

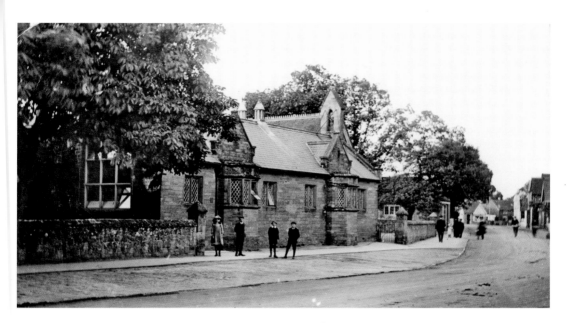

Arts Centre

The National School was paid for from private subscription and opened in 1847 to provide free education for all. The first headmaster was Mr Poore who taught the boys the three 'R's' as well as woodwork and metalwork. The girls were kept in a separate classroom and playground, and were taught by Mrs Poore in the art of needlework and cookery. The growth in population brought about by the railway, among other things, necessitated the addition of two wings in 1870. The school closed in 1964 and was converted to an arts centre for the benefit of the community.

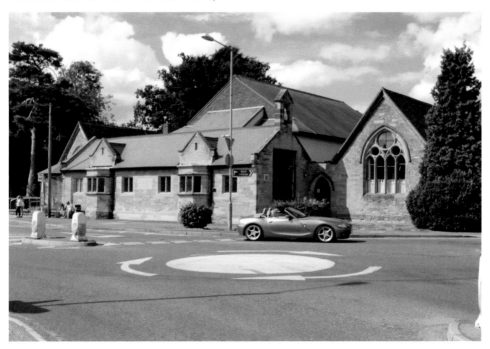

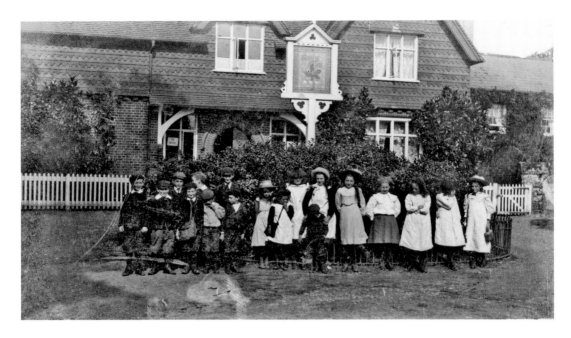

Lady Peek Institute

A row of sixteenth-century cottages stood in Malthouse Lane and served as almshouses supported by the church. In 1885 they were replaced by an institute provided by Sir Henry Peek, MP for mid-Surrey, in memory of his wife Lady Peek. This provided cultural activities such as a reading room, a library and facilities for other gentlemanly pastimes. Today the building houses commercial offices and has been renamed Bullimore's House.

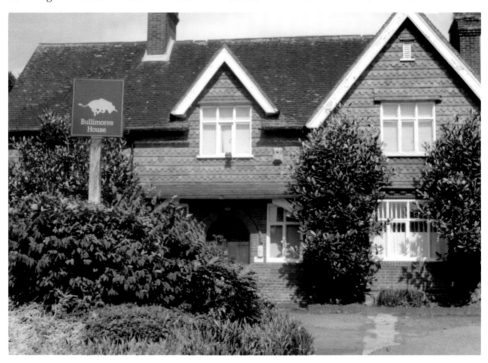

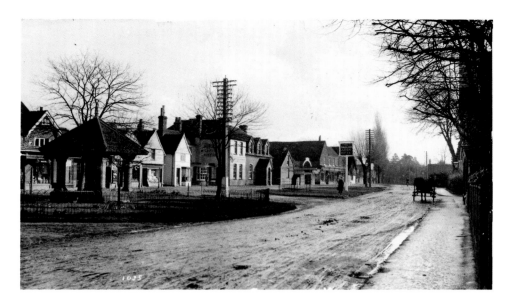

High Street

Cranleigh benefits from a wide High Street with an open space in the centre, the remainder of the ancient common that once penetrated to the centre of the village. The picture dating from the early part of the twentieth century shows the state of the road before surfacing with just the occasional horse and cart passing through. A lone gentleman waits by the inn sign, which shows the name of The Onslow Arms Hotel before changing to The Richard Onslow. The fountain remains a central feature of the village but is surrounded by busy shoppers, some of whom have stopped for outdoor refreshment from one of the nearby cafés.

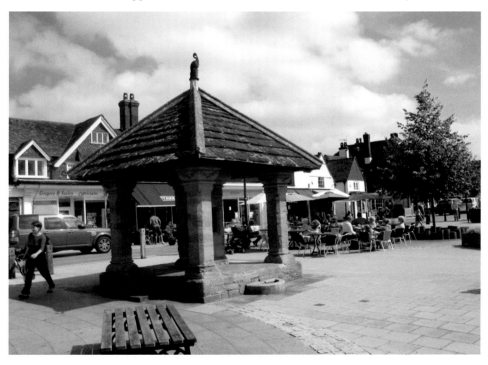

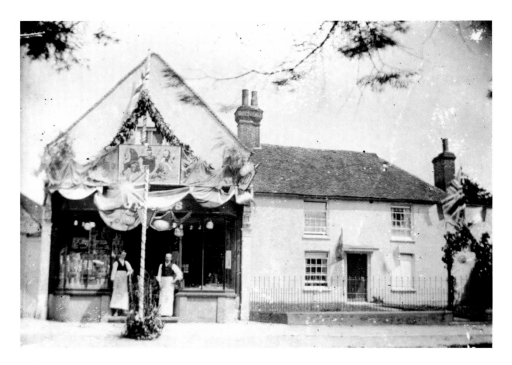

Collins Court

Collins pork butcher's served the community for many decades and Collins pork sausages are still available locally. The old house, which was enlarged to incorporate the shop, was once known as Spittleditch and was the home of the Lee family in the seventeenth century. Original timbers are still visible in the upper storey but the present frontage was added in the Regency period. The picture shows the shop decorated for the Coronation of George V in 1911. The old shop has now been replaced by modern dwellings and the house is used as commercial properties.

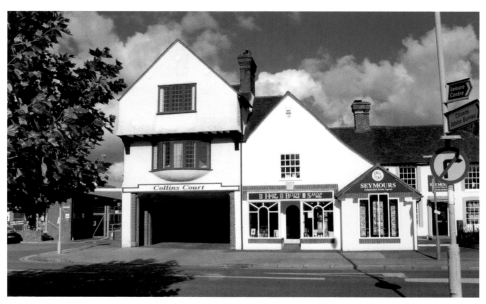

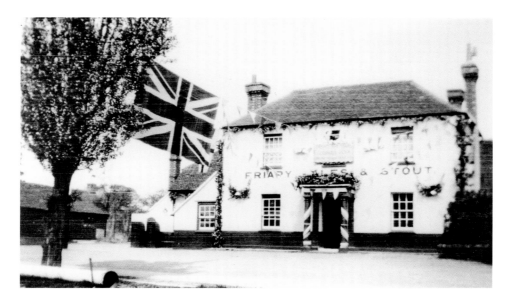

The Greyhound Pub

The old Greyhound public house was built as a neo-Georgian frontage added to a row of timber-framed cottages that had become dilapidated. The pub played an important role in the life of the village as for many years the sports field was situated behind it. The tug o' war team used it as their base and were successful in many local competitions. Our modern Royal Mail post office and sorting office was opened in 1959 and its appearance is typical of the buildings of its time. With the closure of many offices in the surrounding villages the office now serves a much wider community than in former times.

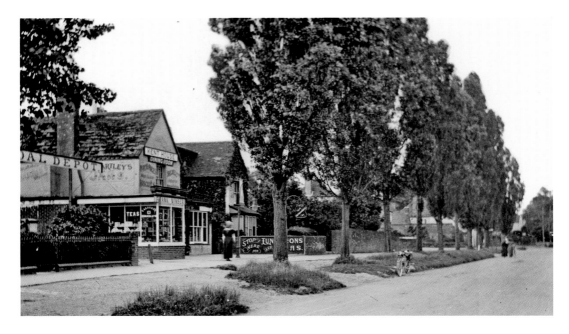

Kent House

Kent House is a substantial building that probably had an important institutional use when first opened. A notable feature of the construction is a large, moulded supporting beam, which carries on through the side wings that are now considered as separate properties. At the beginning of the twentieth century it was occupied by Mr Frank Winser and his tea rooms. Today Kent House remains a prominent presence in the village.

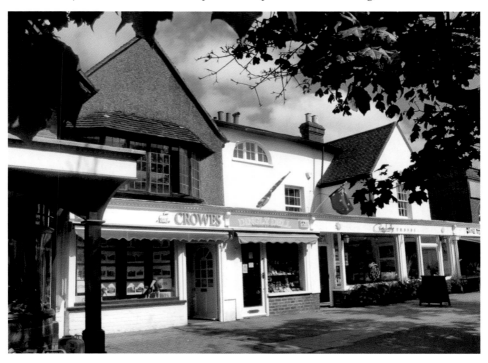

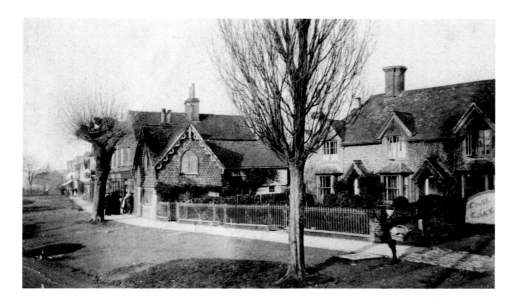

Oliver House

When built in 1560 Oliver House was a timber-framed cottage with a jetty projecting from the first floor to provide some protection for the ground-floor walls and windows. Smoke was channelled up through a large timber-and-daub duct and escaped through a louvre in the roof where the chimney now stands. In Victorian times it was owned and occupied by the Holden family who were the builders at the time and it was they who rebuilt the frontage, added hanging tiles on the first floor and incorporated dormer windows in the roof. Remnants of the old building can still be seen in the joists of the coffee house and an exposed wall panel in the right-hand shop.

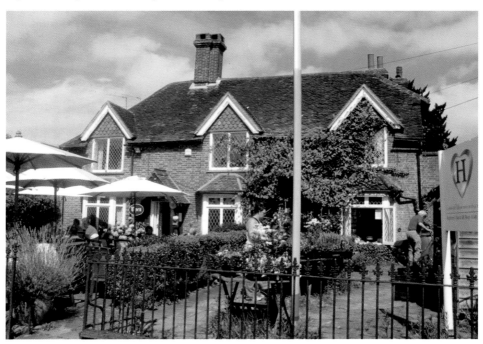

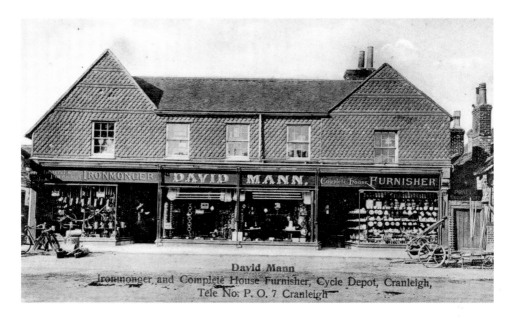

David Mann
Ironmonger and Complete House Furnisher, Cycle Depot, Cranleigh,
Tele No: P. O. 7 Cranleigh

Mann's of Cranleigh

Mann's department store has served the community for more than 125 years since David Mann purchased half of the original frontage and began with a small ironmongery store. In the early days the firm built their own bicycles known as the Enterprise. Throughout the twentieth century the business expanded and the adjacent Cromwell Cottage was incorporated as the present china and glass department. More recent investigations have revealed the presence of a cottage dating from the Tudor period in the heart of the shop and the left-hand entrance leads into a cross-wing built around a hundred years later. This once housed the village school of Mr Thomas Child and the 1841 census shows the presence of sixteen boarders. The frontage has changed little from when it was added by David Mann in 1905.

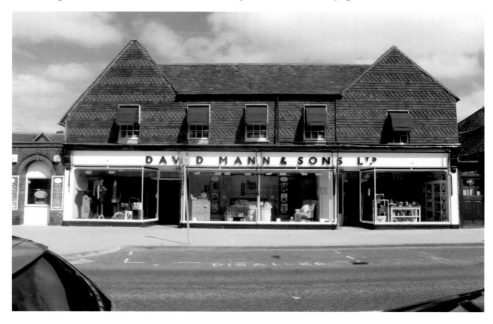

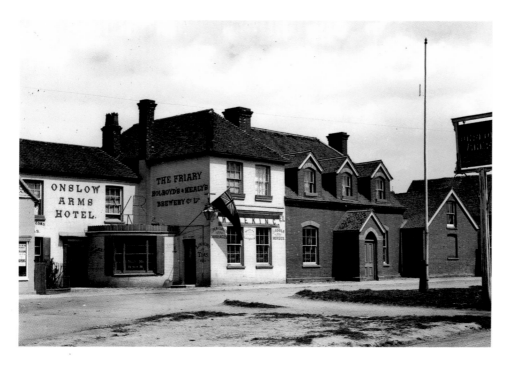

The Richard Onslow

Until recently this hotel was known as the Onslow Arms but is now named after Sir Richard Onslow of Knowle who fought in the Civil War and became Speaker of the House of Commons. The Inglenook bar was once the open bay of a cottage dating from the sixteenth century. During recent refurbishment of the upper storey an almost complete timber-framed bedroom was uncovered, which is now available for occupation. The picture shows the hotel decorated to commemorate the relief of Mafeking in 1900. Now the porch has been removed and the new name displayed.

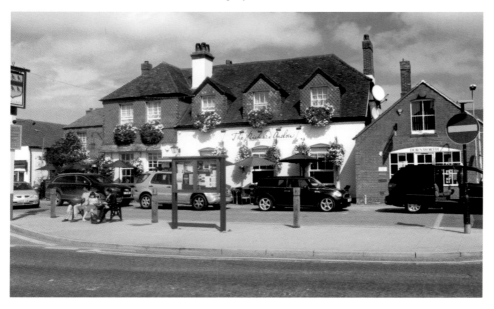

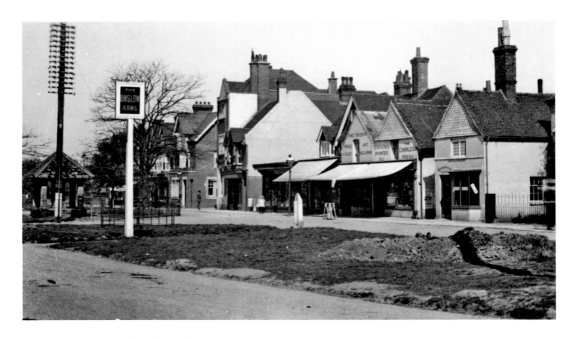

The Camera Shop/Bookshop

At first sight the three shops with their gable ends onto the road appear to be built at the same time but the central one is much older as indicated by the external timbers. Internally, substantial jowl posts and wind braces indicate a date in the sixteenth century, but no means of heating could be found, which leads to the supposition that this was built for agricultural use – probably as a cart shed for the adjacent Ivy Hall Farm.

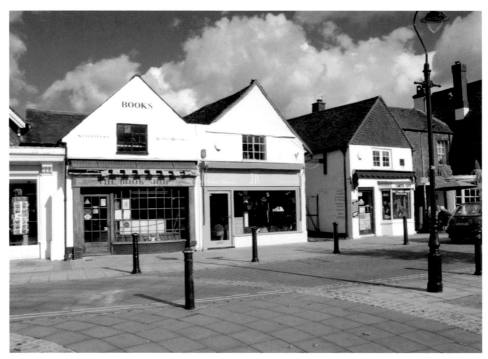

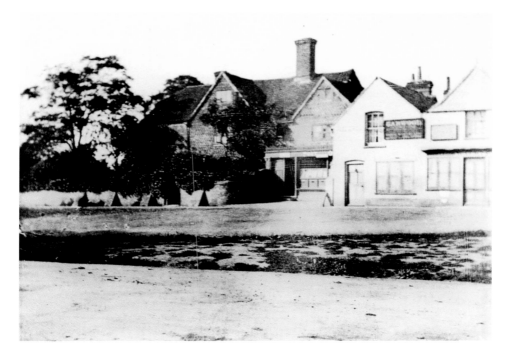

Ivy Hall Farm

Ivy Hall Farm has stood in a prominent position on the northern side of the village for several centuries. It was a working farm in the 1870s with a large barn standing on the common where the war memorial now stands. In 1887 the barn was demolished as part of a clean up to mark the Golden Jubilee. In the 1890s the eastern end was sold off to become the village post office. The present frontage at street level was added by Stephen Rowland at the end of the nineteenth century and became the local grocer's and post office. The decorative corbels and head board can still be seen. Above the shopfront are two asymmetric gables and tile hanging so typical of the High Victorian style in the village.

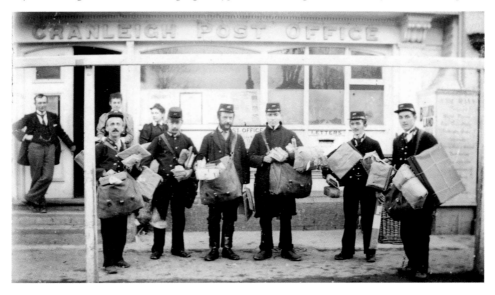

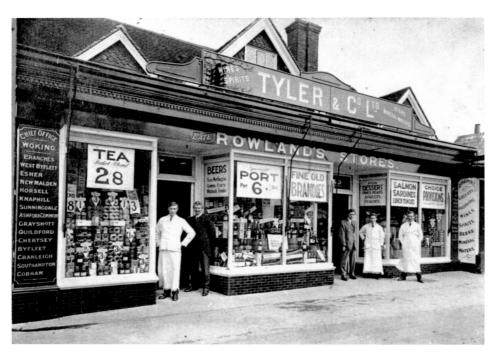

Tyler's

Rowland's Stores was later taken over by Tyler's, a traditional grocer's, still fondly remembered by many villagers. Now the premises have multiple occupations and inside some of the original substantial timbers from the old farmhouse can still be seen.

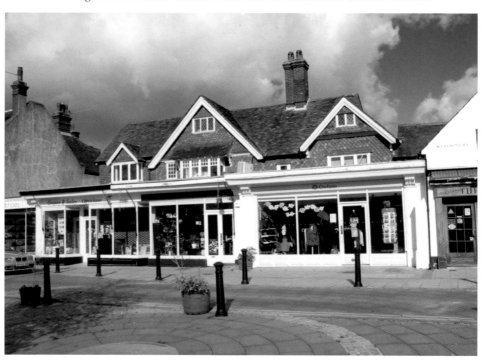

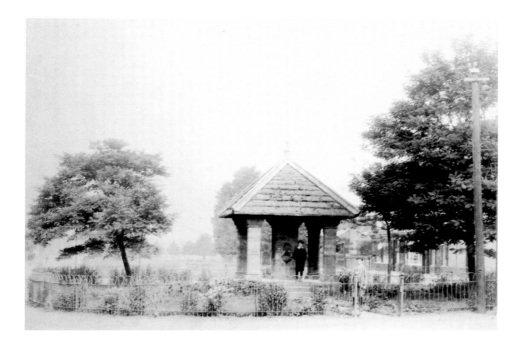

The Fountain

The Fountain is one of Cranleigh's iconic structures donated to the village by the Bradshaw family of Knowle in memory of their son Arthur Hibbert Bradshaw. The columns and central section are built from local sandstone with a Horsham stone roof surmounted by a crane and basket. When built, it provided fresh water to the thirsty villager as well as a welcome for weary travellers. Today the fountain overlooks the pleasant open space known as Fountain Square where one can enjoy *al fresco* eating and beverages other than fresh water.

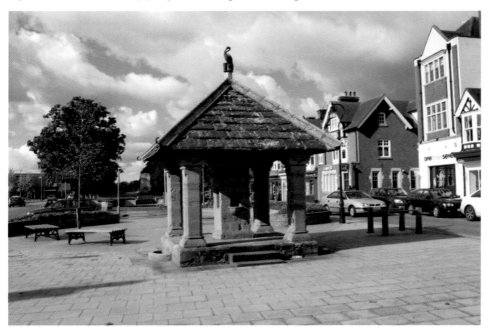

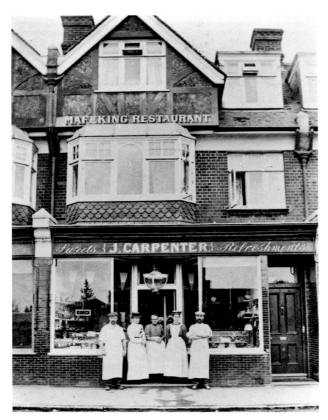

Bank Buildings
The parade of shops known as Bank Buildings is a reminder not only of Lloyds Bank but also the London & Counties Bank, which once occupied the opposite corner of Rowland Road. Once again the architecture is typical of the late Victorian Surrey vernacular and each shopfront displays its own individual features including curved glass windows. The old postcard shows J. Carpenter's bakery, which also served customers in Ewhurst.

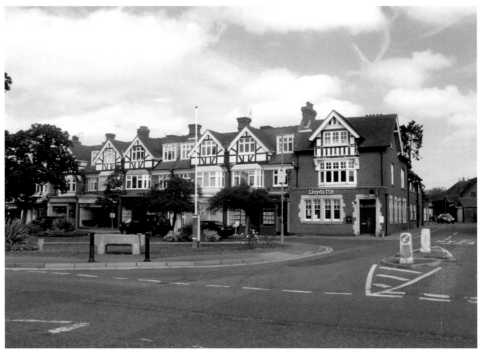

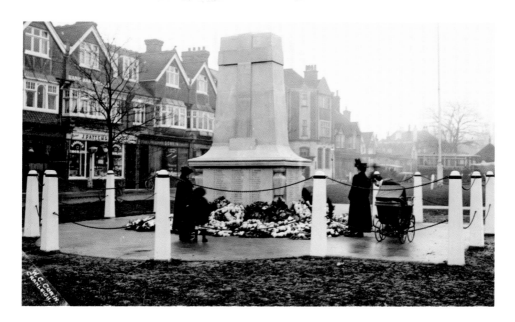

The War Memorial

The war memorial bears a passing resemblance to the Cenotaph but is an essentially Christian effigy. It was paid for from public subscription, erected by local builder Thorpes, designed by Waterhouse and consecrated by the Revd Cunningham in December 1920. Many families lost at least one of their young men in the First World War but particularly poignant is the family of Greenfield who lost three brothers in the Battle of the Somme all within the space of a few weeks. Two tablets were added after the Second World War and on one a name has been erased. This was a member of the Steadman family who was assumed killed but arrived home safely after the memorial had been engraved necessitating its rapid erasure.

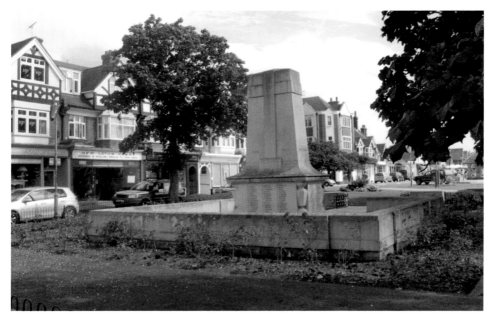

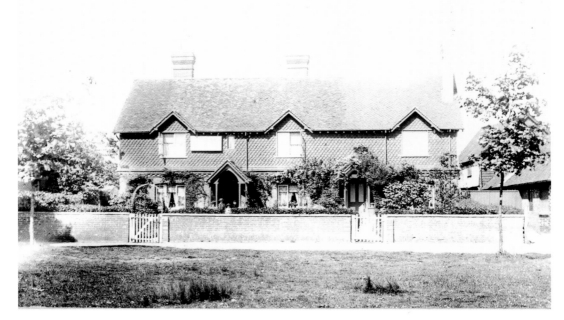

Forge Cottage

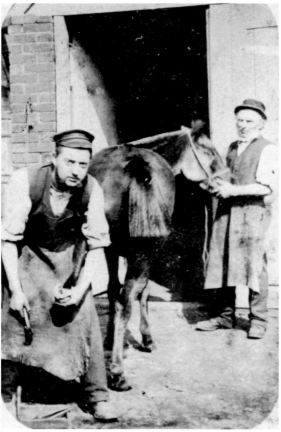

The present terrace of three cottages
was once comprised of only two built
in the 1870s. Laurel Cottage on the
left was the home of Mr Squelch,
the Fly proprietor and his family.
The right-hand cottage was once the
home the Trussler family, one of three
blacksmiths working in the village. The
three sons were Shadrack, Meshack
and Abendego – appropriate names for
those working with the fiery furnace.
The picture shows old Meshack with
his son Michael shoeing a horse.

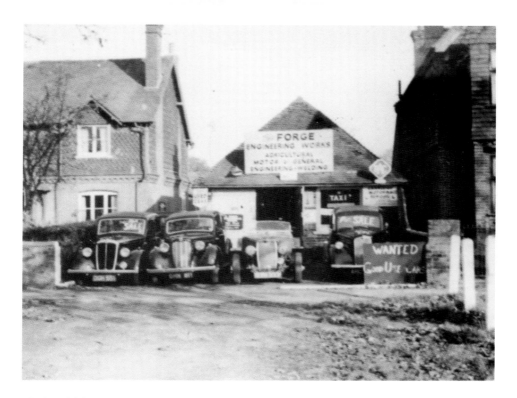

Blacksmith's Forge

The blacksmith's forge continued under the ownership of Mr Frank Charman until the 1950s. When the forge closed the premises were taken over by Mr Seymour's second-hand car sales and repair business. This business proved unfavourable to the neighbours and the old forge was demolished and Maple Tree Cottage was added later; the only visible sign that it is not coeval with the other two is a slight variation in the brickwork.

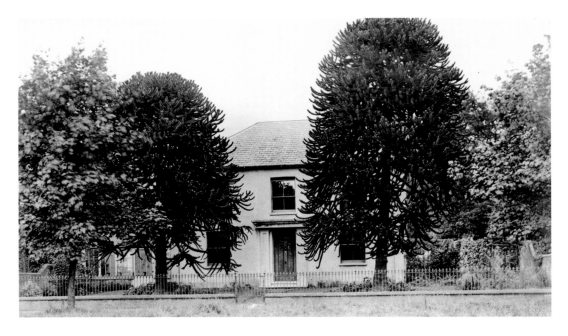

The White House

Overlooking the common, the architectural style of the White House contrasts somewhat with its neighbours. It was built in the 1870s by the local wheelwright James Puttock, and his son Thomas lived there until his death in 1906, aged eighty-nine. By the time this picture was taken in 1910 the monkey puzzle trees, fashionable in Victorian times, largely obscured the house. The property has been enlarged in modern times by the addition of two wings.

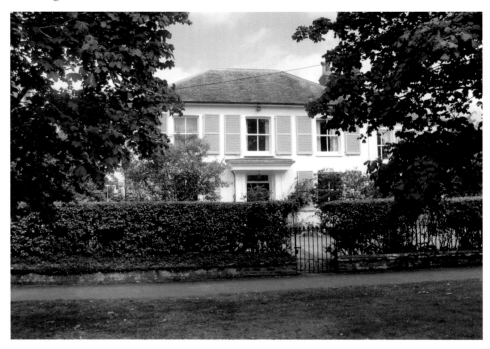

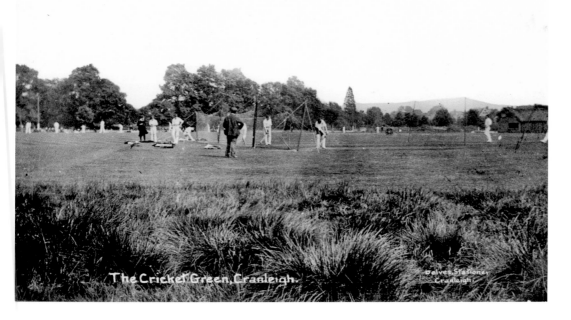

The Cricket Green, Cranleigh.

The Cricket Ground

Cricket has been played on the common for over 160 years and the Cranleigh Cricket Club was founded in 1859. Since that time a number of well-known players have trod the turf; particularly notable was the occasion of the centenary when many of the England test side appeared. Mr Hillman Attwell, the local pharmacist, took all nine celebrity wickets. The old pavilion was built with a thatched roof, and when this unfortunately caught fire it was replaced by the present brick-and-tile building. The clock was purchased by public subscription and unveiled by Frank Swinnerton who lived in Old Tokefield at the opposite side of the field.

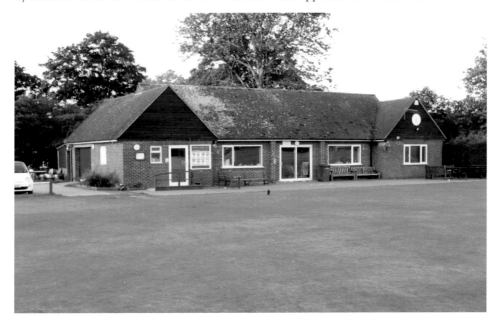

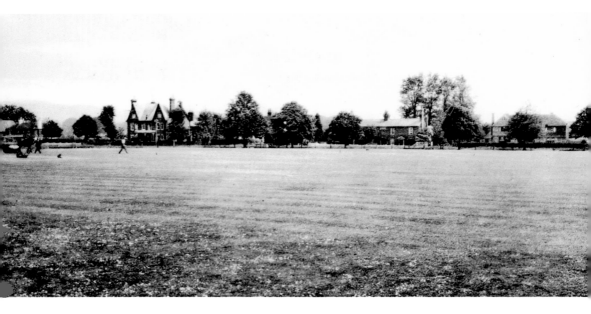

Chapel Place

This panoramic view across the common looks towards Chapel Place, a charming terrace of three early nineteenth-century cottages. On the right is a 1930s house known as Briarfield, once the home of former Surrey and England cricket captain Peter Barker Howard May. This charming watercolour painted in 1998 shows the character of the early nineteenth-century cottages with their period porches, wicket fence and unusual bifurcated chimney stacks.

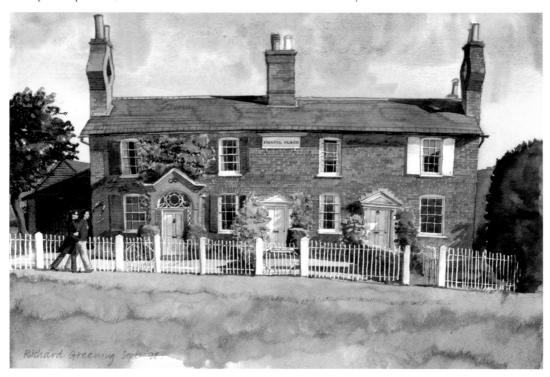

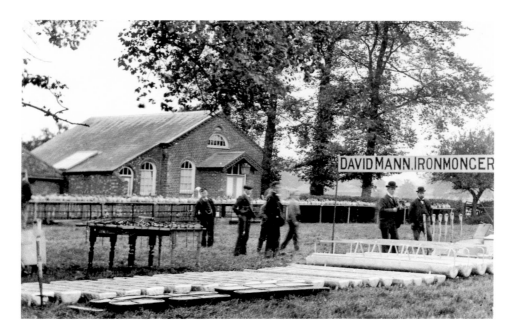

The Chapel

The old chapel was originally built in 1828 by George Holden as the first Congregational chapel in the area. Later the congregation split into various groupings and the main stream carried on under Charles Barringer, eventually moving into a larger Baptist church at the western end of the High Street. For a period the old chapel building was used by David Mann's as a warehouse. When this photograph was taken it appears that some of the wares have been placed outside, possibly in anticipation of a sale. In 1987 the old chapel was sold by the trustees and converted into a private residence. This necessitated the exhumation of a number of graves, including many of the Holden family, which were re-interred in the parish cemetery. The whole process proceeded under close supervision but not without protests from local residents.

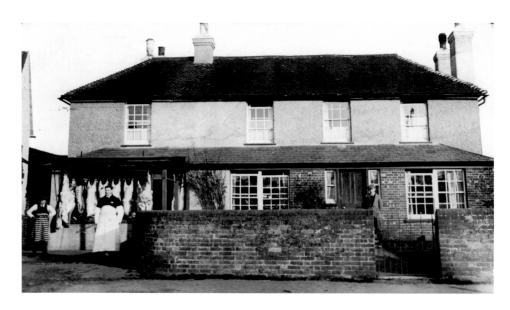

Common House

Continuing along the right-hand side of the common the triangle of grass narrows to a point where an ancient pond stands. Over the centuries this would have served to water the commoners' animals and swell the wooden wheels on their wagons. The common is triangular in shape and the points served as funnels so that the grazing animals could be rounded up to be sent to market or moved to their winter quarters on higher ground in the hills. This area is overlooked by Common House, once an important farmhouse, with a large barn and fields behind which are now the playing fields for Cranleigh School. In the twentieth century Common House was the premises of Brown's the butcher's and later Smallridge's before they moved to a new shop in the High Street.

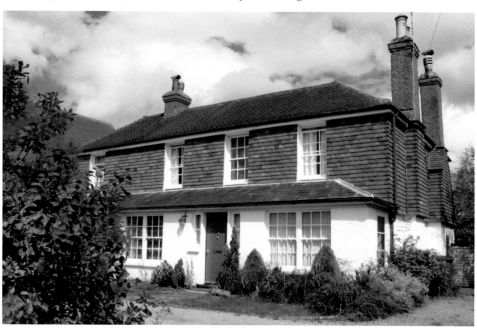

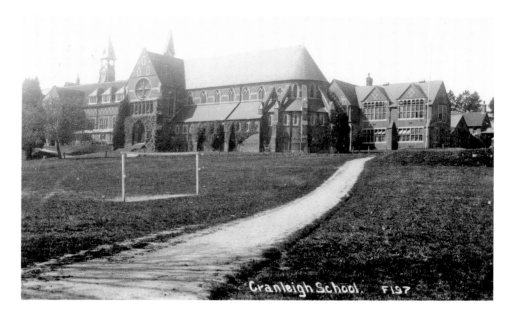

Cranleigh School

Cranleigh School, or Surrey County School as it was first known, was built to a design by local architect Henry Woodyer. The foundation stone was laid by the Archbishop of Canterbury in 1863 and the school opened in 1865 for the sons of middle-class families. The building was erected in Cranleigh to coincide with the arrival of the Horsham to Guildford railway, but the school opened in September and the railway did not arrive until October. Hence instead of the anticipated 100 pupils only 18 of the 25 enrolled arrived, no doubt giving much displeasure to the first headmaster, Revd J. Merriman.

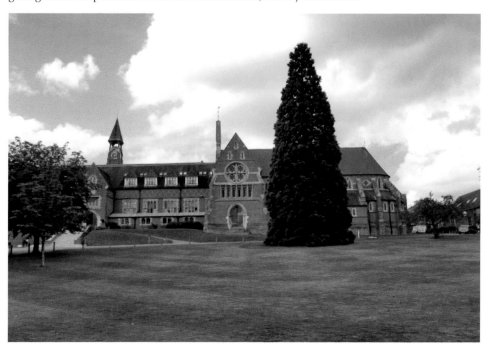

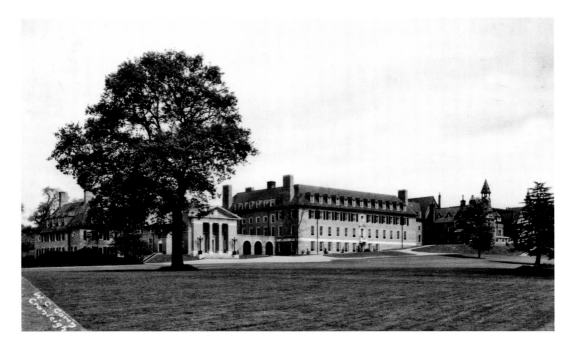

Cranleigh School
The new speech hall was added in 1929 and named the Connaught Building, after the Duke of Connaught who was an occasional visitor to the school. Today the school is one of the leading private schools in the country with over 500 pupils, around 100 of which are girls.

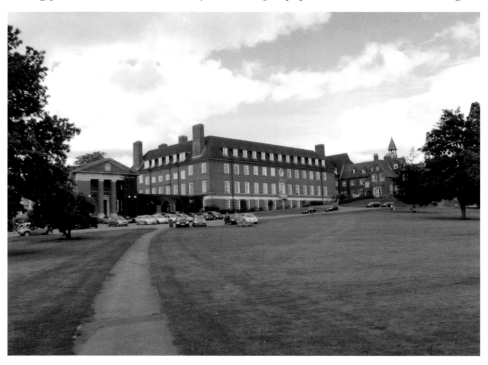

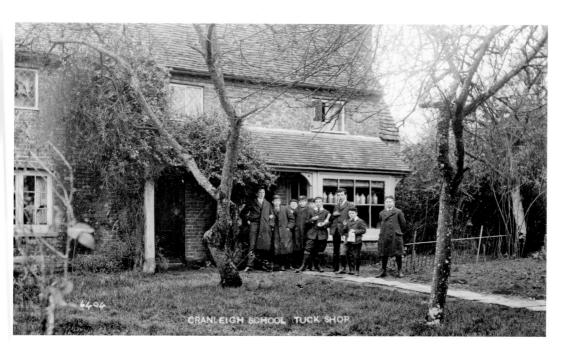

CRANLEIGH SCHOOL TUCK SHOP

Tuck Shop

The school tuck shop opened in 1866. It was presided over by a Mrs Ede and was a great comfort to the boys. Later a Mrs Mould took over, serving hot drinks, shakes, toffees and cakes that could be consumed in the garden in fine weather or in the stables when wet. The shop remained in the same cottage until 1936 when a new shop was opened in school grounds. The house still stands but has reverted to residential use.

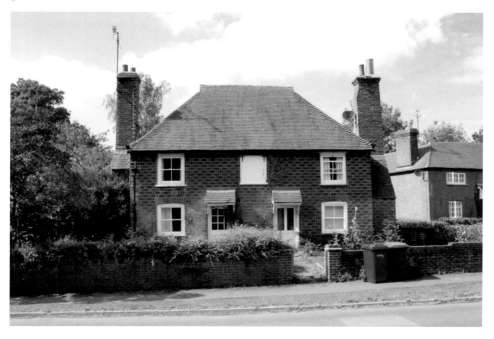

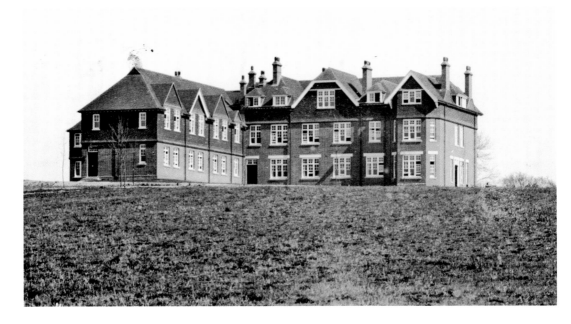

Cranleigh Preparatory School

The preparatory school was built on a hill facing the main school and opened in time for the academic year of 1913. Among the more notable students were the four sons of artist W. Heath Robinson who was living locally at the time. As a token of thanks the artist painted four sketches caricaturing life at the school. The rather stark appearance of the building when first built has been softened over the years by tree planting.

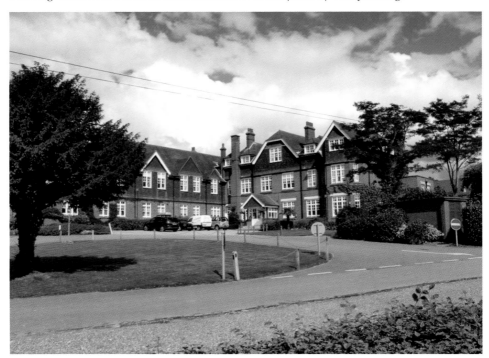

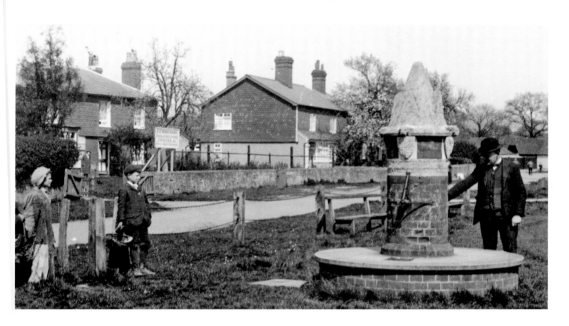

Fountain

The fountain on the common was erected to commemorate the Golden Jubilee of Queen Victoria in 1887. It was funded by subscriptions from the old boys of Cranleigh School and this is recorded in a Latin inscription on the circumference of the monument. Shields represent the royal insignia as well as the badge of the school. The structure is still a feature of the common but no longer functions as a fountain. Its stone is now rather eroded and the inscriptions are barely legible.

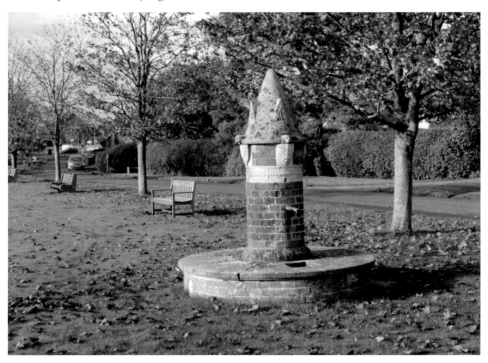

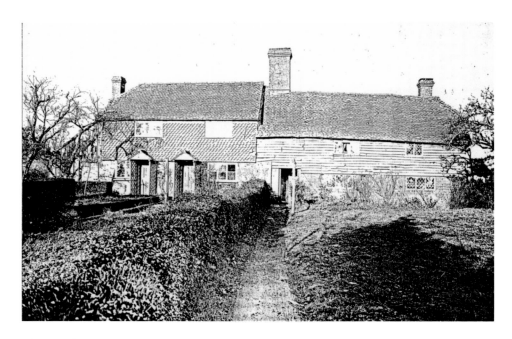

Old Tokefield

There are many fine houses adjoining the common but probably the most noticeable is Old Tokefield, built in the early 1600s. From the roofline it is clearly of two separate builds and the taller left-hand section was probably added later in the same century. The old picture shows the house divided into three separate dwellings and half timbered and tile-hung. This Victorian propensity for covering up the original structure probably helped to preserve the integrity of the timbers and the wattle-and-daub cladding. Today Tokefield has been restored to an appearance similar to how it would have looked when it was built in the seventeenth century.

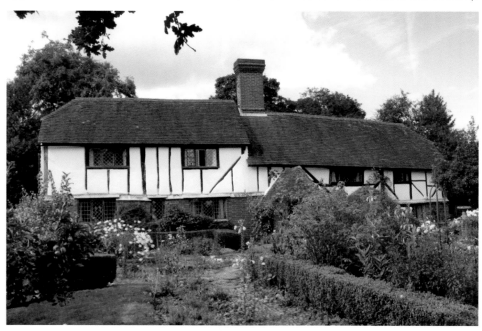

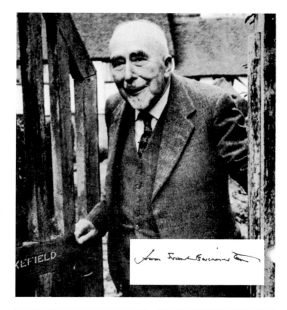

Cranleigh Residents

Two famous Cranleigh residents have lived at Old Tokefield.

Probably the most well-remembered was Frank Swinnerton who moved into the village in 1923 and was attracted to the garden studio where he produced some of his best works. He authored over fifty literary publications, but in his seminal work, *Reflections from a Village,* he describes the life and some of the local characters in Cranleigh. During his time in the village he was a great supporter of the cricket club and the Boy Scouts. He died on 6 November 1982 at Cranleigh Village Hospital.

Prior to Swinnerton, the house was occupied by the artist Lawson Wood, famous for his illustrations to children's books and a series of comic postcards often depicting policemen and inebriated gentlemen. His series showing animals in comic situations was so well drawn that he was eventually awarded the fellowship of the Royal Zoological Society.

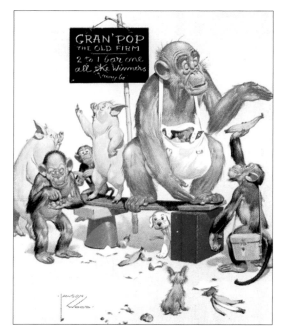

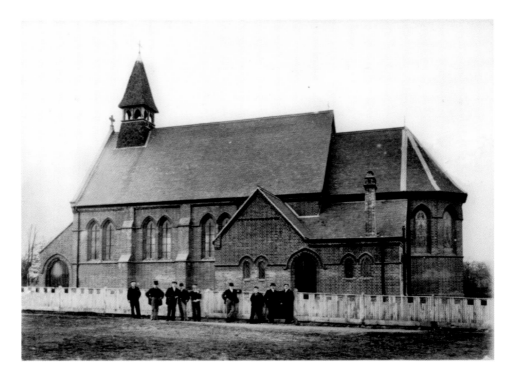

St Andrews Church

An additional church for the benefit of parishioners at the western end of the village was proposed in 1897 to mark Queen Victoria's Diamond Jubilee. It was built and furnished from voluntary contributions at a cost of £2,300. Work was completed in 1899 and the church was dedicated by the Bishop of Winchester. The church and meeting room were demolished in 1975 and the present senior citizens' accommodation was built in its place.

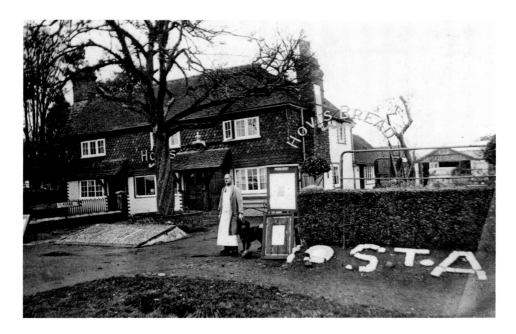

St Andrews Bakery

The Old Bakery is housed in a fine seventeenth-century house. The picture shows the baker Mr Pirie with his dog, standing outside and looking towards the old windmill where the flour for the bread was ground. Mr Pirie was the projectionist when our first cinema was set up in a tin hut on the other side of the common. The house still stands in a prominent position overlooking the common and the stump of the old tree remains.

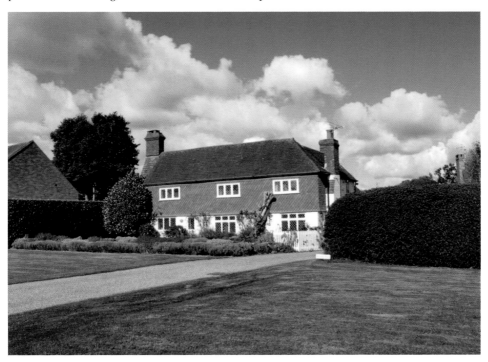

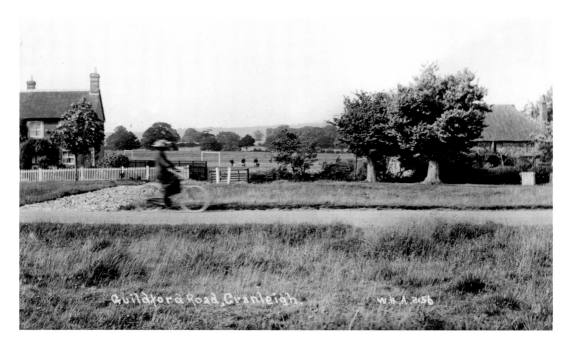

Mercers Cottage

On the north side the Guildford Road, tucked away behind St Andrews House, is a charming cottage known as Mercers, named after previous owners. This is a fine medieval cottage substantially unchanged since the fifteenth century. The view to the school playing fields is now obscured by later building.

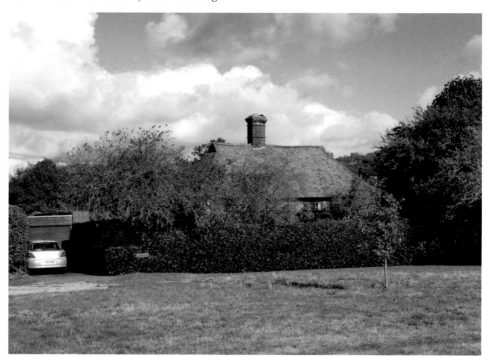

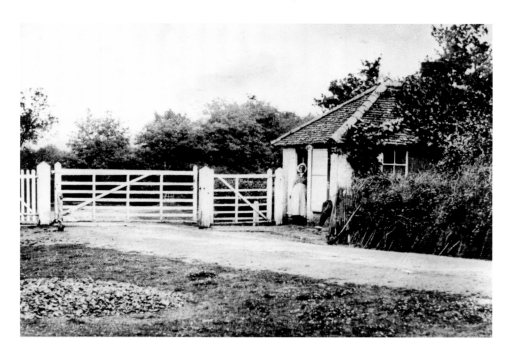

Toll House

The toll house at Gaston Gate was one of several *en route* from Guildford to Horsham. The keeper in the 1870s was Mrs Ketcher and the tolls were abandoned soon after this picture was taken. Another turnpike would have been encountered in the village and yet another in Ellens Green. Few villagers could afford to pay the fees and all manner of deviations were devised to avoid payment. As a result the enterprise was unsuccessful and shareholders lost their investment. The old toll house has been converted into a bungalow and is just visible behind a high hedge. Modern traffic is allowed to pass without hindrance.

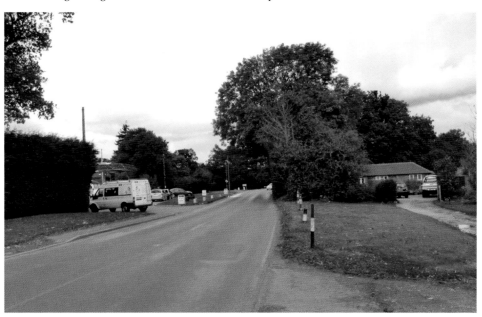

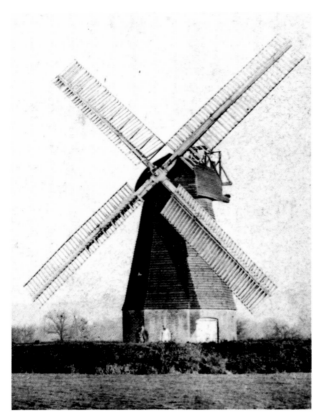

Windmill

The old windmill stood on the common until 1917 when it was demolished and much of the timber reused in the renovation and expansion of many houses in the village. The octagonal structure with the Kentish cap dates from around 1800, but this probably replaced an earlier building.

The millers in the latter half of the nineteenth century were the Killick family. The picture is an enlargement of a small *carte de visite*. The buildings at the base of the windmill are still in use as commercial premises.

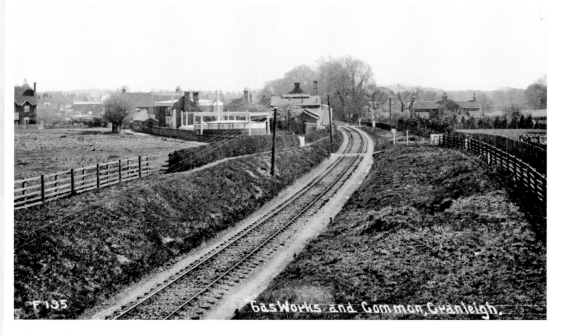

F 195 GasWorks and Common, Cranleigh.

Elmbridge

This view from the old railway bridge looking towards the old gasworks would have been the first landmark encountered by the rail traveller from Guildford. Now the old gasworks have gone and growth obscures much of the old view. The old railway trackbed is part of the Downs Link and is an open-air facility enjoyed by walkers and cyclists alike.

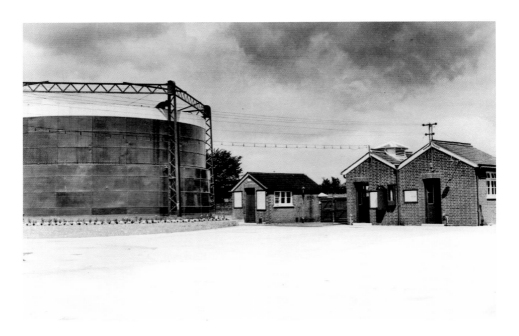

The Old Gasworks

The gasworks was one of the innovations of Stephen Rowland. He recognised the importance of utilities such as gas and water to the successful growth of the village. The gasholders were a feature of the landscape and one was struck by a V1 rocket in the Second World War – the resulting explosion killed Mrs Ede who lived in the nearby cottages. The gasworks remained in production until the introduction of North Sea gas in the late 1960s. For some time one of the gasholders remained as pressure regulator. The old industrial site has now been developed as a rather pleasant housing complex.

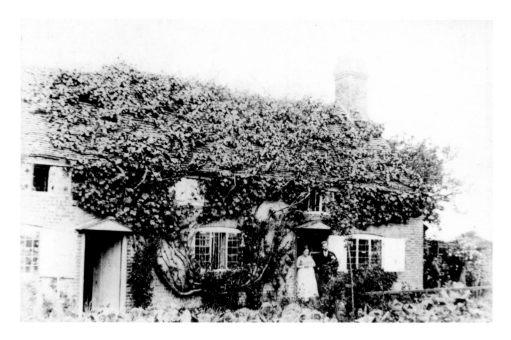

Vine Farm

Passing over the railway bridge the land on the left was once part of the ancient Vine Farm. The old farmhouse was once the home of Mr and Mrs David Mann before they moved to their shop premises in the High Street. The old farmhouse is still in use as office premises but the farmland has now been built on. The large industrial estate is rather unsightly but provides much needed employment in the area.

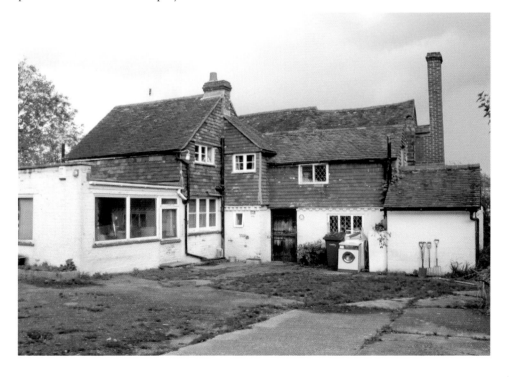

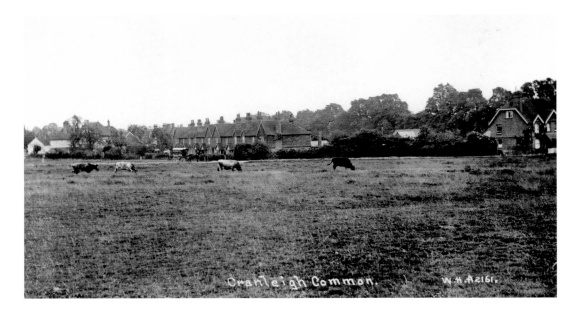

Parkgate Cottages

Parkgate Cottages were built in the 1880s as a fine example of a Victorian terrace. The name derives from the fact that at one time an exit drive from Knowle Park terminated on the common but was no longer used once the railway cut through it and Knowle Lane became the main access. The picture shows Mr Pirie's bakery delivery van while cows graze on the common. The Parkgate Cottages remain much as they were built but parked cars now replace the grazing cows.

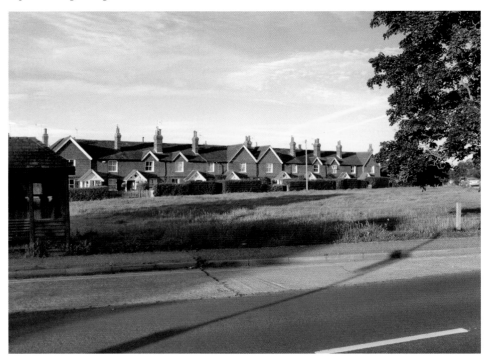

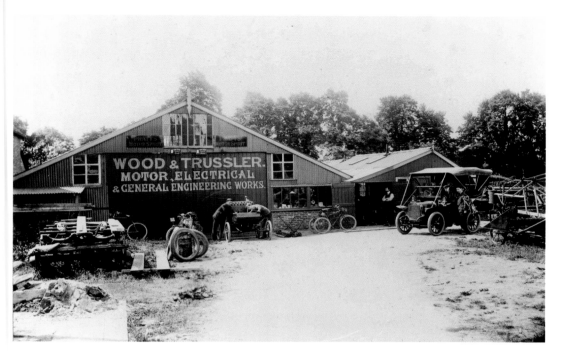

Trussler's

Originally blacksmiths, the Trussler family adapted to the coming age of the motor car. The gentleman in the car is Walter Albert Trussler, son of Shadrach, and the car is a 1904 Renault, symbolic of the success of the family business. The weather-boarded shed is still in use and a whole industrial complex has now grown up on this part of the common.

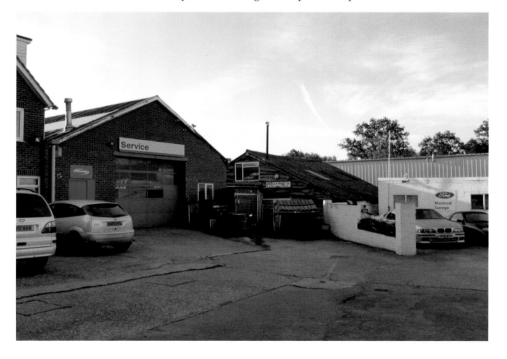

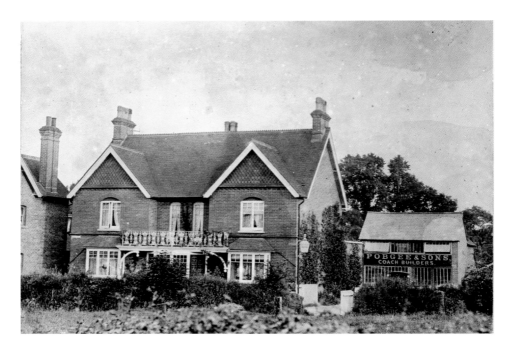

Pobgee's

Before the age of the motor car the more wealthy families would be able to order a carriage to meet their requirements from Pobgee's coachbuilders on the common. The grand house with the balcony to the left of Pobgee's is Grantley House. The house has retained its balcony but the coachbuilder's has now been replaced by a modern motor garage.

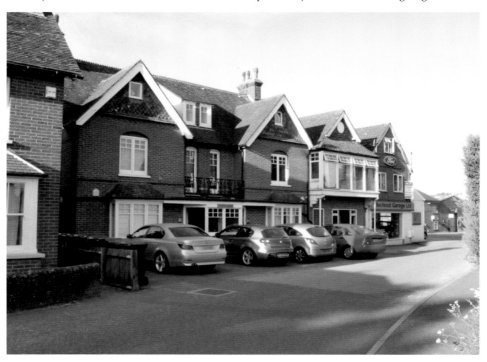

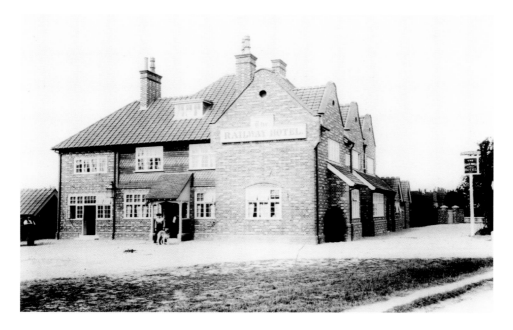

Cranley Hotel

The Cranley Hotel began life in 1870 as the Railway Hotel in anticipation of increased influx of travellers borne on the trains of the London, Brighton & South Coast Railway. The Dutch-style gables are a pleasing relief from the angular gables that proliferate in the village. The hotel's name is a reminder of the old spelling of the village name before it was changed in 1867 to avoid confusion with Crawley.

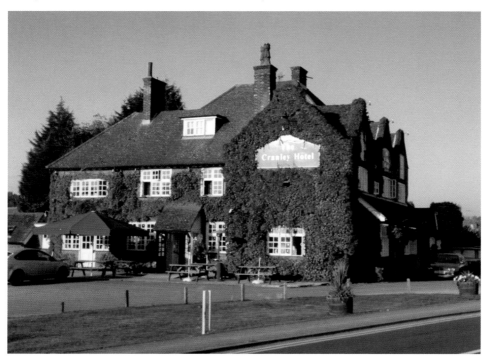

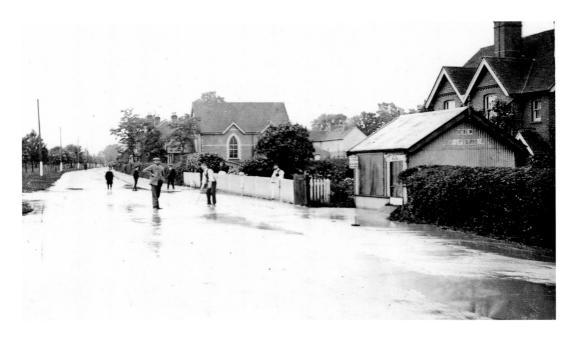

Floods

Floods have occurred regularly in Cranleigh, a possible hangover from prehistoric times when the whole area was once part of a huge riverbed. This scene from 1903 shows some resigned villagers trying to cope with the adverse conditions. The building on the right is Tree Gate House where the local children flocked to buy their sweets. Improvements to drainage have reduced the risk of flooding in later years, but the old pond remains, if somewhat overgrown.

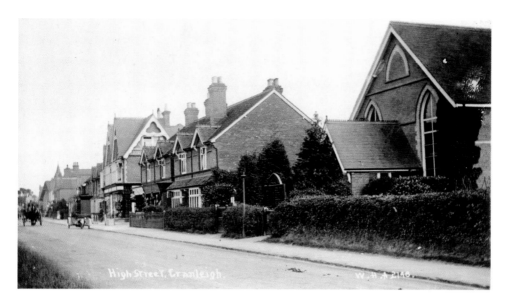

Baptist Church

The old Baptist church dating from 1889 can be seen on the right with its tall lancet windows typical of the period. The shops at the upper end of the High Street have seen a number of different occupants over the years but their structure remains largely unchanged. The photographer was Mr W. H. Appleby who produced a series of postcards of the village and his three-wheel car can just be seen in the background. A new church was completed in 2007 and in addition to religious services the main hall offers a splendid space for musical events and other rooms are available for smaller meetings.

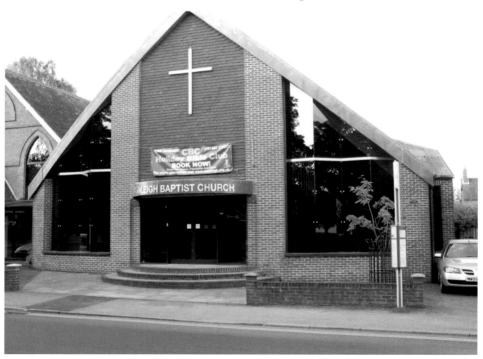

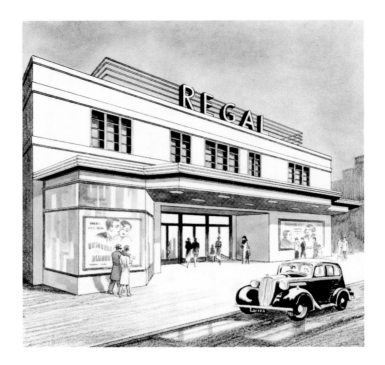

Regal Cinema

The Regal cinema opened in October 1936 but many improvements to the projection system and seating were made in its lifetime. It replaced the Central Picture House in the centre of the village, which showed silent films from 1913 and was converted to sound in 1930. This in turn replaced an earlier corrugated-iron building and villagers recall that when it rained on the corrugated-iron roof or a stream train passed by the sound of the music was drowned out. The Regal continued long after many other cinemas of similar size had closed, due in no small part to the skill and dedication of the owners Bernard and Pat Tonks. Various attempts were made to save the cinema from closure but a successor could not be found to take it on and it closed in 2002 to be replaced by residential development known as Pavilion Court.

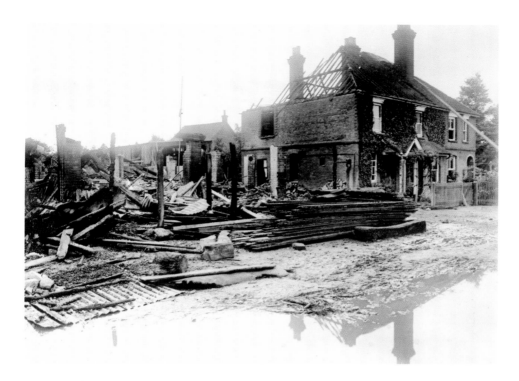

St James Place

The building firm of F. Warren & Sons moved to premises in St James Place on a site previously occupied by Messrs E. & J. H. Holden. These premises were in turn destroyed by fire, after which Warren's moved to a new site in the High Street. Warren's had their own joinery shop, employed a large number of staff, and were responsible for many of the better timber-framed buildings built in Cranleigh between the wars.

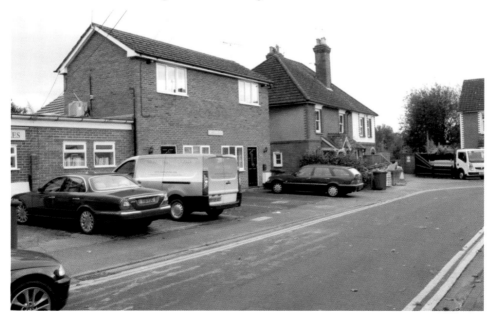

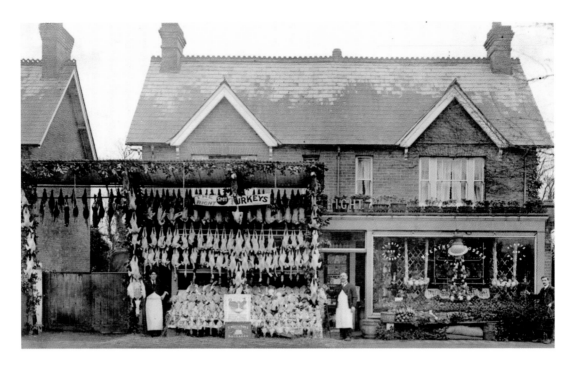

C. Hights

C. Hights fruiterer's and poulterer's is seen in this publicity picture with a splendid display of turkeys and other poultry presumably in time for Christmas. Mr Charles Hight stands proudly beside his wares and reproduced this picture as a postcard to promote sales.

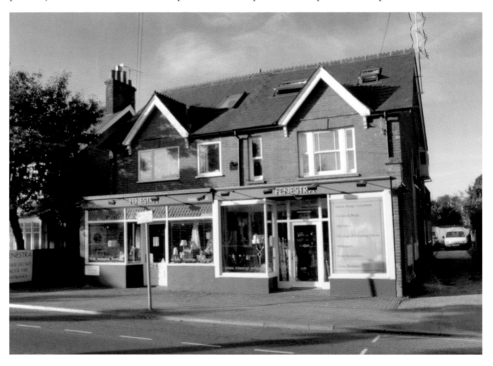

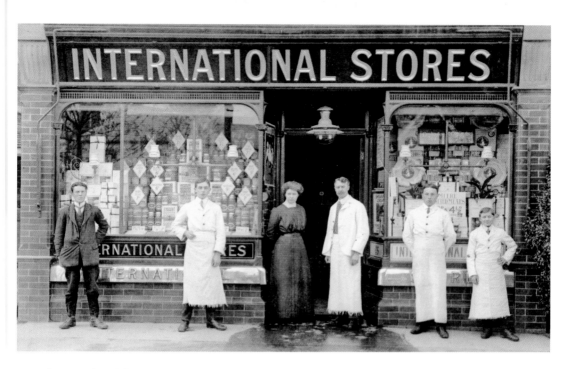

International Stores
The International Stores began life as Kearley & Tonge, later the International Tea Company. The founder Hudson Ewbanke Kearley was educated at Cranleigh School. The shop continued in Cranleigh into the 1970s and was later replaced by an Indian restaurant.

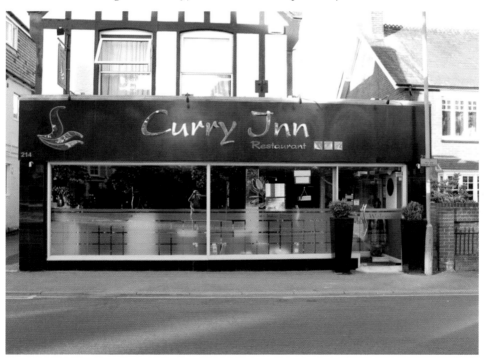

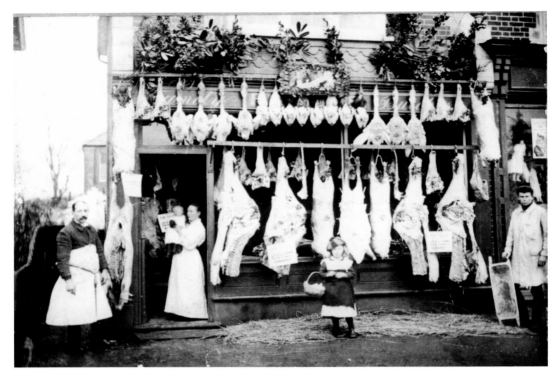

Cross Butchers

Mr Robert Cross opened his butcher's shop in the High Street during the 1880s, one of several in the village. He is seen here with the frontage dressed probably for the Coronation of Edward VII in 1902. His wife Fanny makes sure the baby is in the picture and daughter Ruth poses specially for the photograph. The shop frontage remains largely unchanged but the shop has now been put to a more modern use.

J. Mann

Jesse James Mann was the youngest son of David Mann, the local furnisher's and ironmonger's. Born in 1883, he worked for the family firm for most of his life, despite being badly gassed in the First World War. His occupation in the 1911 census is given as house furnisher and his wife Sarah Ann is the confectioner, so it is she who is presumably running the shop along with the tea room at the back. The shop was originally owned by Jesse's uncle, and also Jesse so perhaps the sign over the shop has not been changed. The little girl peeping out of the door is Doris Andrews, the much younger sister of Sarah.

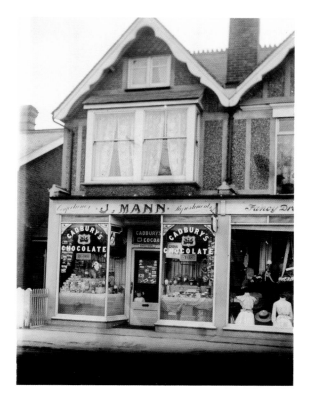

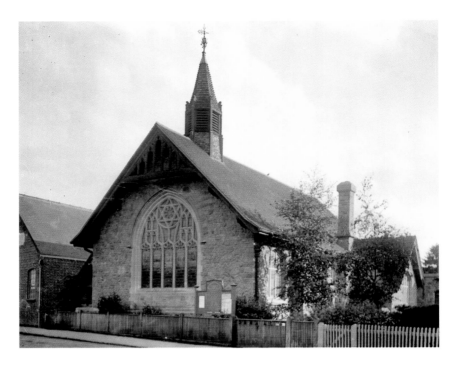

Methodist Church

The Methodist church was built in 1904 on the site of an older mission hall. It is aligned at an angle to the High Street and the entrance porch is on the side. The approximate cost of the building was £2,000 and funds were raised locally. Mrs E. A. Holden was an early proponent of Methodism in Cranleigh and she probably persuaded her husband to influence the firm of Holden's to undertake the building project, which was completed in six months.

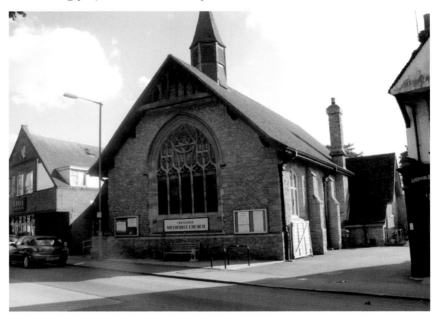

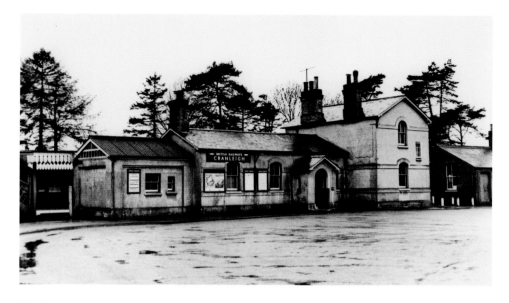

Station

The Horsham to Guildford Direct Railway began operations in 1860 and opened in 1865 in the ownership of the London, Brighton & South Coast Railway. A passing loop was added in the 1880s so that Cranleigh became a terminus for some trains. The station approach is seen here with ample parking for commuters. The line was closed as part of the Beeching Axe in 1965. The last train ran on 12 June and, despite efforts to save the line, the track was pulled up and the station buildings demolished. Stocklund Square now stands on the site of the station and the car park replaces the sidings and coal depot. The only remnant of the station is the platform level, which can still be seen at the rear of the shops in use as a loading bay.

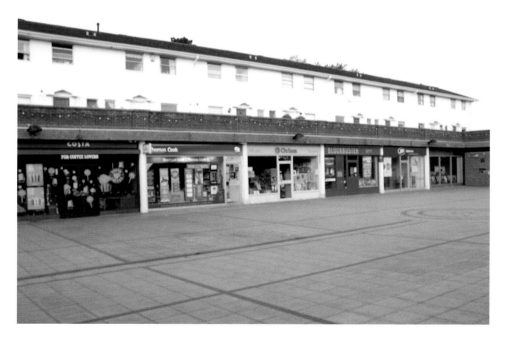

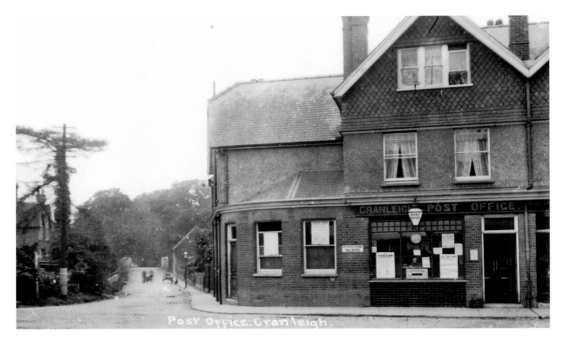

West Knowle Lodge

Two lodges were built at the head of Knowle Lane by William Hanham after he had built his Italianate mansion in Knowle Park. The West Lodge was the home of Cranleigh's third post office and telephone exchange. Since the opening of the modern office the old lodge has seen new occupants including a restaurant in the old telephone exchange.

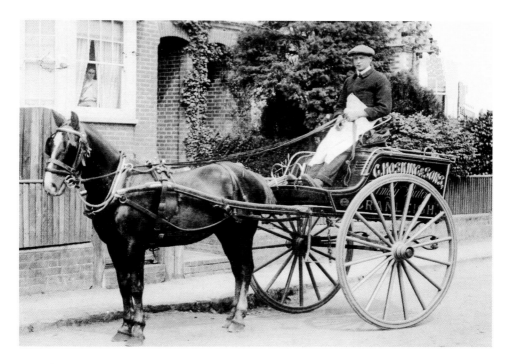

Knowle Lane

Knowle Lane was previously known as Crow Lane and provided access to many farming settlements to the south of the village. With the reopening of Knowle Park in 1832 the road was widened and straightened to provide a prestigious entrance drive. The picture shows G. Hoskins butcher's delivery cart in Knowle Lane.

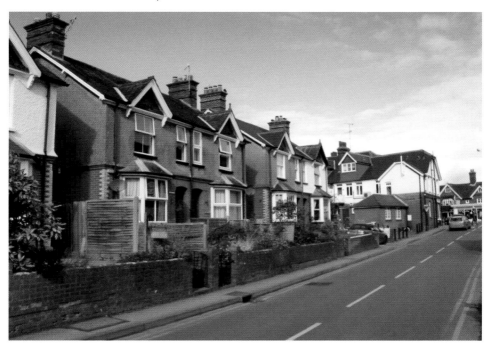

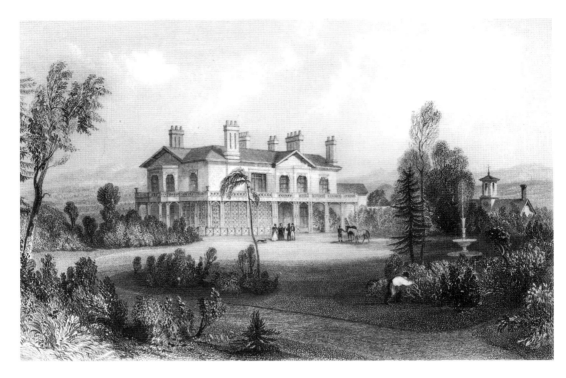

Knowle House

Knowle became home to the Onslow family in 1559 when Richard Onslow from Shropshire married Catherine Harding, heiress to the estate. It is said that Oliver Cromwell visited Sir Richard Onslow, grandson of the first incumbent, and granted a charter to hold a fair in thanks for the villagers who hosted his entourage. The Onslows decamped to Clandon Park later in the seventeenth century and the old Tudor mansion was left to deteriorate until the estate was purchased by William Hanham. The present Italianate-style house dates from 1823. The house was occupied and enlarged in the twentieth century by the Bonhams and later the Berdoe-Wilkinsons. It is now put to good use as a care home for senior citizens.

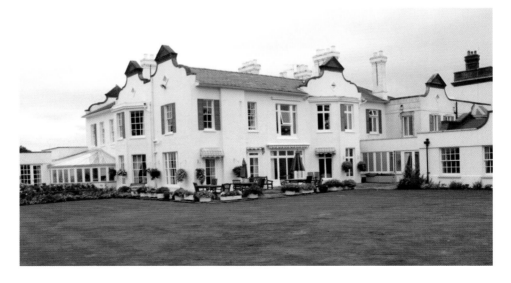

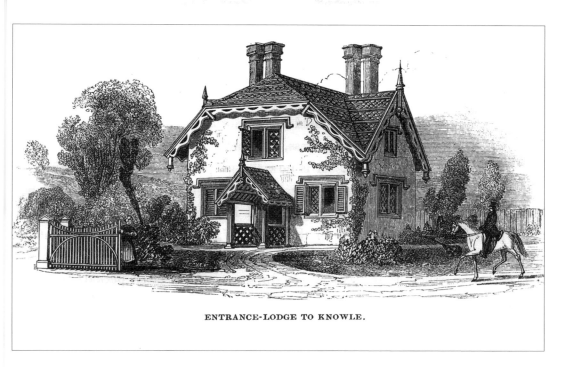

ENTRANCE-LODGE TO KNOWLE.

Entrance Lodge

The original entrance lodge was a highly decorative design typical of the early part of the nineteenth century. The building remains at the entrance to Knowle Park but many of its original features have been lost.

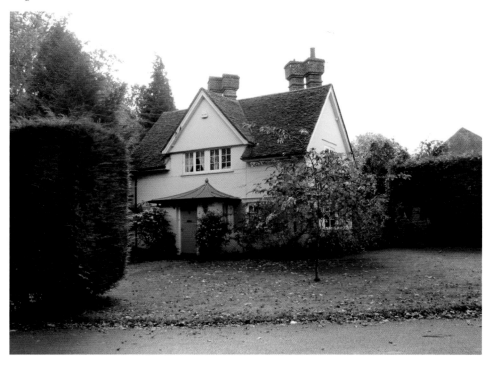

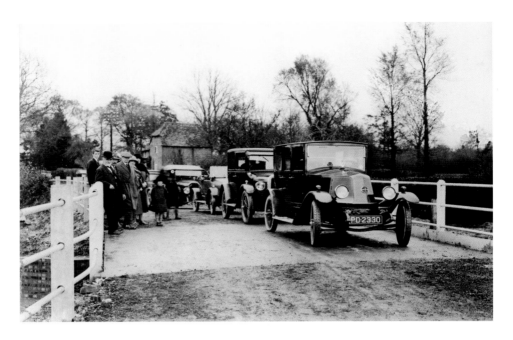

Bridge Opening

Many of the roads in Cranleigh were crossed by small streams with an elevated walkway for pedestrians. While these were satisfactory for horse-drawn traffic they proved problematic for motor vehicles. Warren & Sons were responsible for building this bridge in Knowle Lane near the properties known as Waterbridge and Waterland. This picture shows the opening of the Bridge with Mr Frank Warren in the foreground and a procession of cars led by a 1920s Renault. The bridge survives heavy commercial traffic today and provides access to local residents. In the background is Waterland Cottage once the home of test pilot Neville Duke.

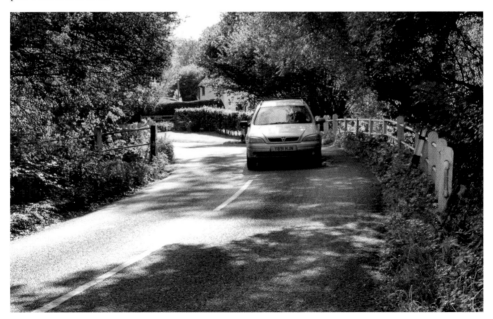

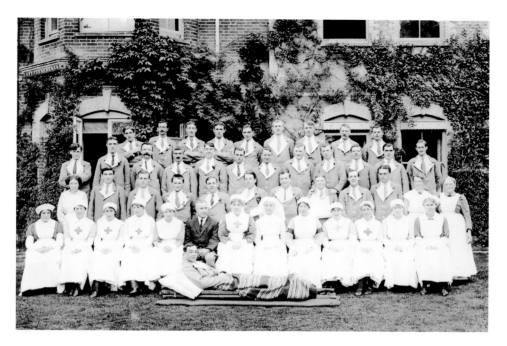

Oaklands

Oaklands was a rather grand double-gabled Victorian pile standing in large garden designed by Gertrude Jekyll. It was owned by the Rowcliffe family of Hall Place at the time of the First World War when it was put to good use as a Red Cross hospital for injured servicemen. After the war it became a school for young gentlewomen and is now a development of luxury apartments.

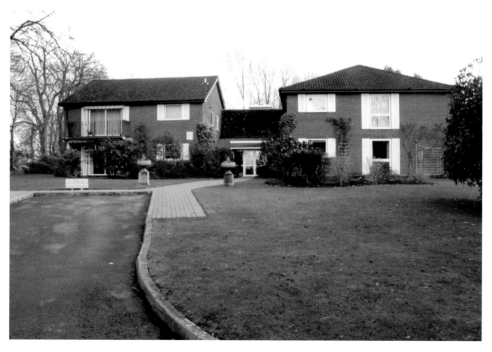

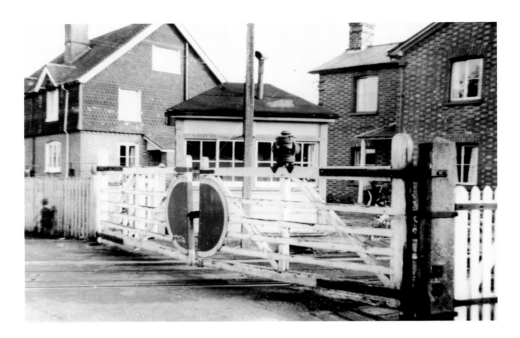

Level Crossing and Gatehouse

The Horsham to Guildford branch line crossed Knowle Lane via a level crossing with gates. A gatehouse was built to provide a home for the crossing keeper and a box in the garden to house winding gear to open and close the gates. Many residents recall that Mr and Mrs Charman were responsible for operating the gates on average twenty-four times a day when the bell rang to warn of a forthcoming train.

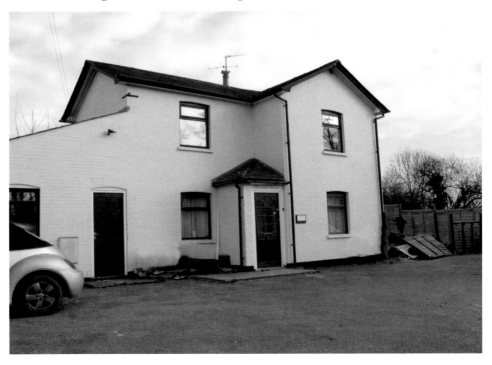

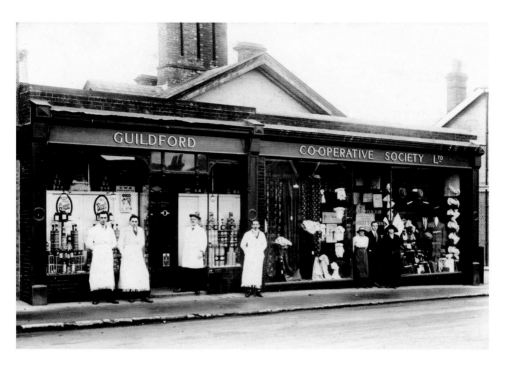

East Lodge

East Lodge was once the premises of the Miss Elliot's the milliner's. In living memory it was the Co-operative stores selling every sort of wearing apparel from woolly hats to Wellington boots. The old shop was demolished in the 1990s to make way for more modern buildings.

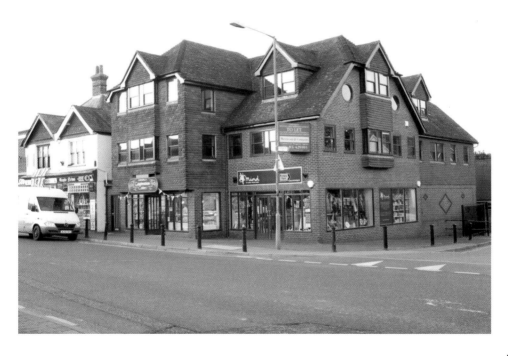

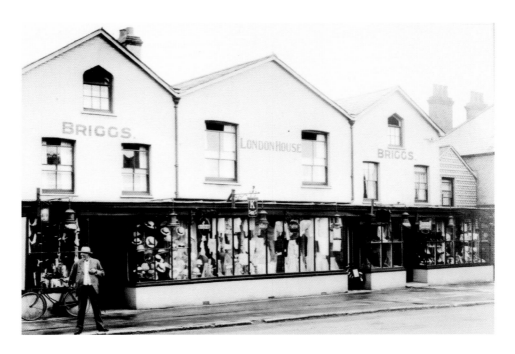

Briggs London House

Many locals have fond memories of Briggs clothes shop, and later Gammons who sold everything for the dressmaker including textile cloths, cotton threads and knitting wools. Money was passed to the cashier through a pneumatic system of containers that ran around the stores.

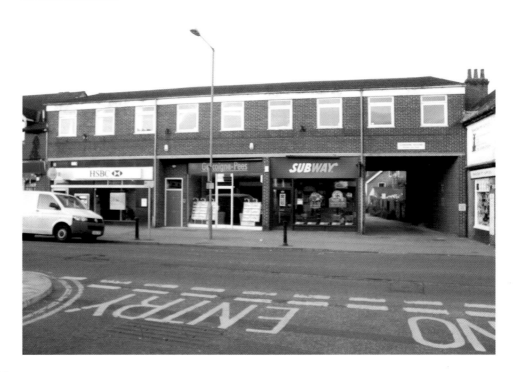

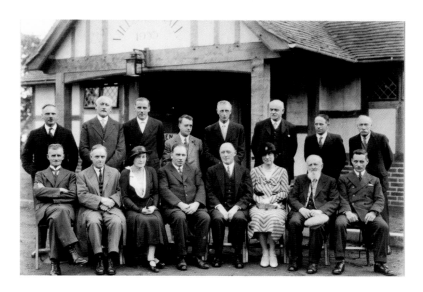

Village Hall

After the First World War subscriptions were raised locally for a suitable memorial. Some subscribed to the war memorial but others preferred to support a more practical outcome to the village community at large. Land was given by the Chadwyck Healeys of Wyphurst and the building was constructed by Warren's in a half-timbered mock-Tudor style. For various reasons the opening was delayed until 1933 and the ceremony was attended by the great and the good of the village. The picture shows standing: Mr E. S. Warren, Lt-Gen. Sir Alfred Bingley, Revd Hugh Johnston, Mr A. B. Johnston, Sir Eric Bonham, Mr J. B. Waldy, Mr Reeves and Mr Whittington; and seated: Mr H. E. Pryke, Mr Wade, Lady Bingley, Mr S. Mann, Sir Gerald Chadwyck-Healey, Lady Bonham, Mr Stephen Rowland and Mr J. Gale. Today the village hall looks very similar in appearance to when it was opened. It now sports a metal sculpture erected to mark the Millennium and the paved area conceals a time capsule interred at the same time. Over the porch is a weather vane in the form of a crane, donated by the Cranleigh-Vallendar Friendship Club to commemorate twenty-one years of twinning with our German partners.

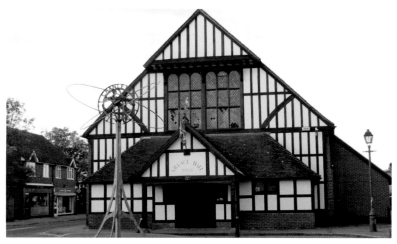

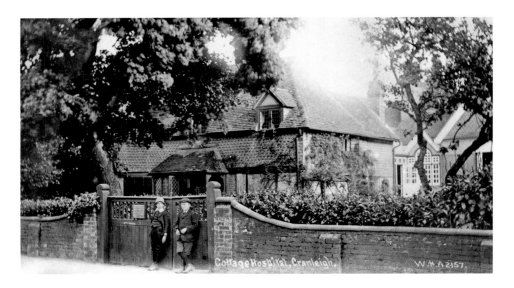

Village Hospital

The village hospital, opened in 1859, is the oldest in the country still in operation. The old cottage was donated by Rector Sapte and the first manager was Dr Albert Napper. Napper was descended from a long line of local farmers and became recognised nationally for his pioneering work in establishing local community hospitals. The early history of the cottage is unclear but it remains one of the finest timber-framed buildings in Surrey, and was recently dated by dendrochronology to an original build of 1446. The original building has been enlarged over the years to cope with an increasing demand for services. Most of the costs have been borne from local subscriptions and the League of Friends has provided additional equipment and support, even after administration was handed over to the NHS in 1949. A modern health centre is now open and a new hospital is planned, which leaves the future of the old hospital in some doubt, but a return to community use remains a possibility.

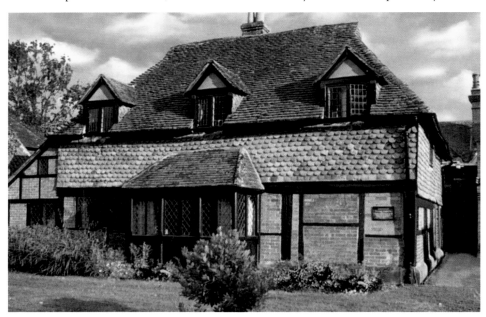

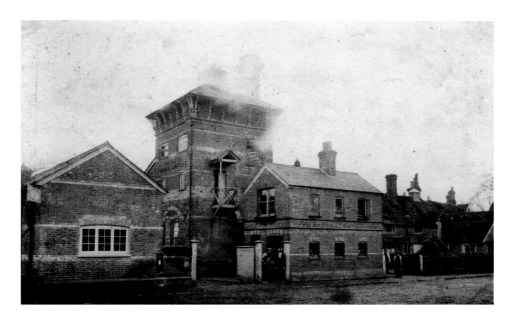

Brewery

The Three Horseshoes public house dates from the seventeenth century, and the name alludes to the blacksmith on nearby Lucks Green, when the farmer would have slaked his thirst while the horse was being shoed. When Mr George Bruford established the Cranleigh Steam Brewery in 1876 as a local amenity with direct links to the Three Horseshoes public house he adopted this symbol as the firm's logo. Nothing remains of the brewery but the Three Horseshoes public house continues to this day with a new frontage added in the 1920s.

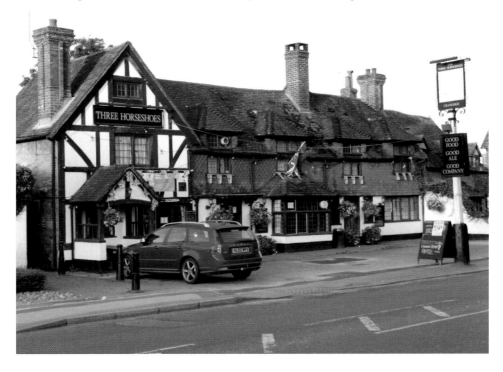

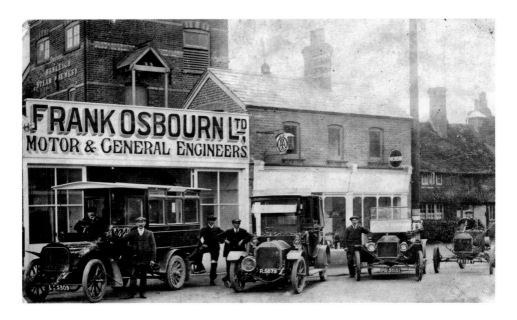

Osbourn's

Mr Frank Osbourn began his agricultural engineering business in the Ewhurst Road where the oriental takeaway shop is now. With the advent of the motor car the business expanded into new premises in the High Street in front of the old Steam Brewery. In the picture taken in 1913, Frank Osbourn is standing by the bus, which ran to Ewhurst twice a week on Tuesdays and Saturdays. At the time the Model T Ford, third from left, would have been the ultimate in motoring affordability. When the brewery closed the buildings were demolished to allow the garage premises to expand even further into what eventually became Cranleigh Motor Co. Ltd.

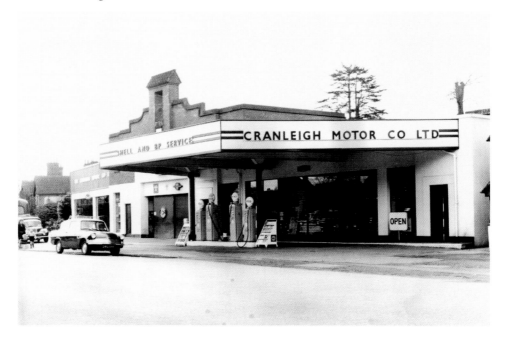

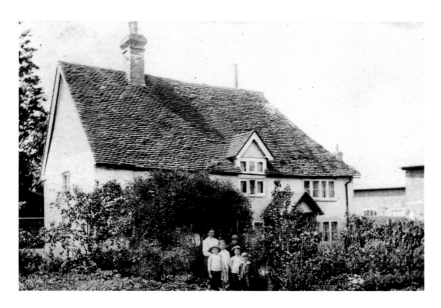

Little Manor

When the site of Cranleigh Motor Co. Ltd was purchased by Esso the old buildings were demolished to make room for the garage forecourt of today. The old cottage, known locally as Little Manor, was revealed and quickly Grade II listed, which saved it from destruction. The old postcard shows it when it was lived in by a family with five children surrounded by a luxuriant, if somewhat overgrown garden. Today it serves as the pay kiosk and convenience shop and, while some changes have been made, the huge structural timbers are still visible on the outside and internally. It was not possible to determine a precise date when it was built but from structural features it would appear to date from the first part of the fifteenth century, making it the oldest building in the village. As such it is a contender for the oldest garage shop in the country.

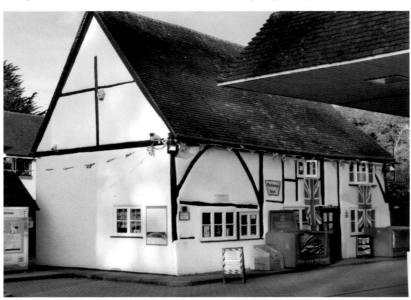

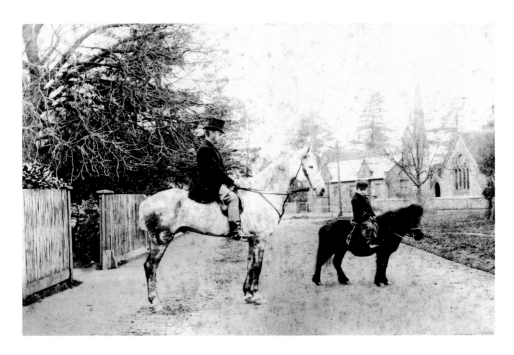

Broadoak I

Broadoak House has one of the finest Georgian façades in the area, although the building itself was probably enlarged from smaller, more modest dwellings. Throughout most of the nineteenth century it was home to the local doctors who modified the house to meet their needs. John and Jacob Ellery were the first recorded inhabitants and they were followed by Albert Napper, who founded the village hospital, and later into the twentieth century by his son Arthur Albert Napper. Arthur was a keen horseman and is seen here on his trusty grey stallion, accompanied by his eldest son Harold on his pony 'Pet'. Harold was born in 1877 and he met an untimely death shortly after this picture was taken. His grave in the cemetery shows that he died in 1892, while a pupil at Epsom College, as a result of a cricketing accident. Below, a view of the back of the house as it looked when the Nappers lived there.

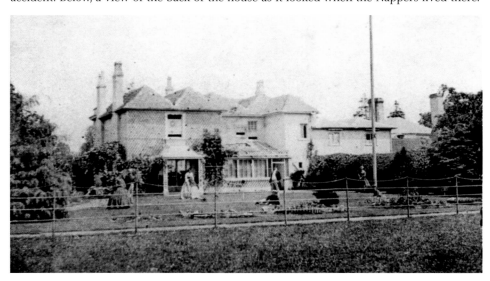

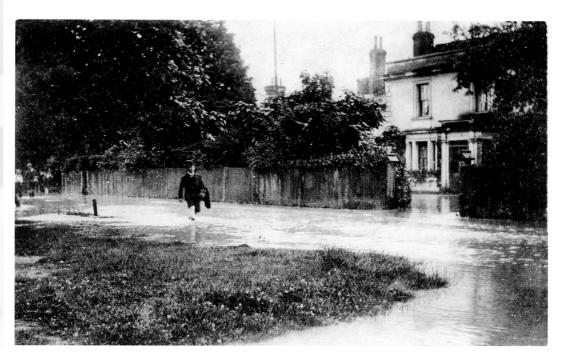

Broadoak II

This postcard from 1906 shows the result of the flooding at this end of the village. One determined traveller, perhaps in a rush to catch the London train, decided the only way through was to remove his shoes and socks and march on. Broadoak today retains a lot of its former features and remains a rare example of Georgian design in Cranleigh.

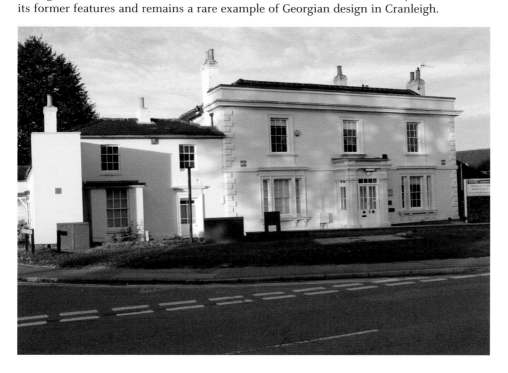

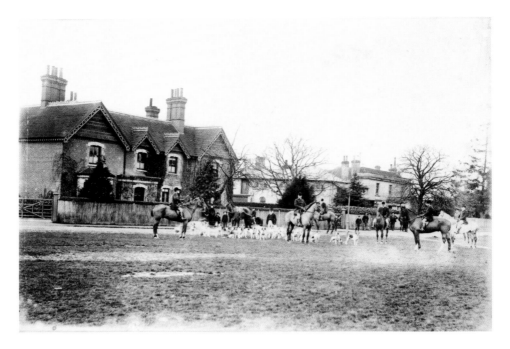

Brookmead

This rather grand house built in the 1880s is now divided up and home to the local veterinary surgeons. The picture shows the hunt meet on Luck's Green soon after the house was opened. Architectural features include pierced ridge tiles and bargeboards, stone coining and segmental arches to the window heads.

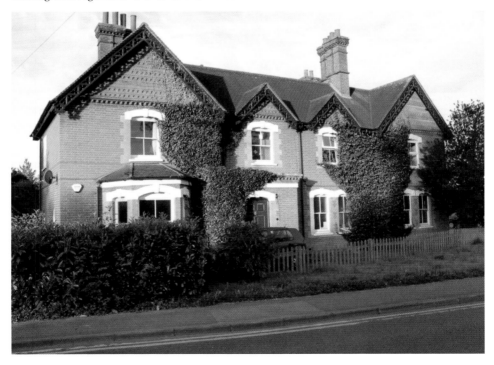

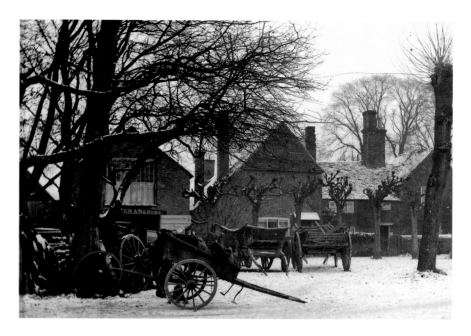

Cheesman's

The family firm of Cheesman's were wheelwrights well into the twentieth century until the motor car and the pneumatic tyre replaced the Sussex wagon and the wooden wheel. The wheelwright's shop occupied the southern quarter of the house known as the Causey. The wooden frames were made in the lower portion and the metal components were cast on site in the backyard. The completed bodies were winched upstairs on long ramps where a painter could add his artistic embellishments in a dust-free atmosphere. The completed wheels were raised up for finishing through a long narrow slot in the ceiling. Today this view is obstructed by the garage of Little Causey.

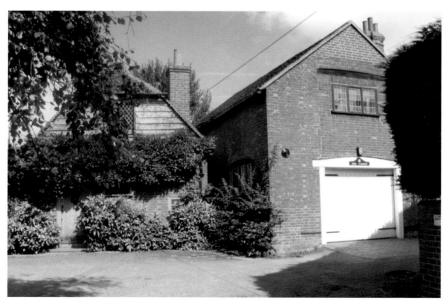

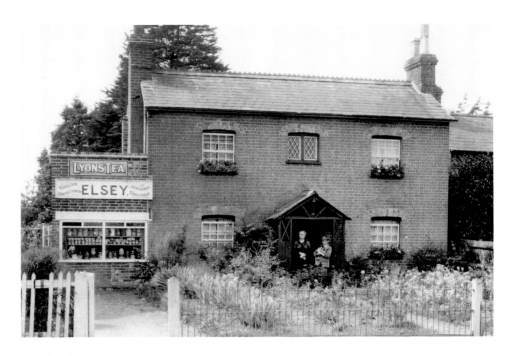

Elsey's Shop

Mr Elsey was gamekeeper to Lord Alverstone, but when illness forced him to retire he and his wife left the Lodge at Winterfold and moved to Cranleigh. In order to provide an income for the family the couple converted their garage into a shop. Today the house, now known as Cherries, still stands but without the shop, which has now been returned to a garage.

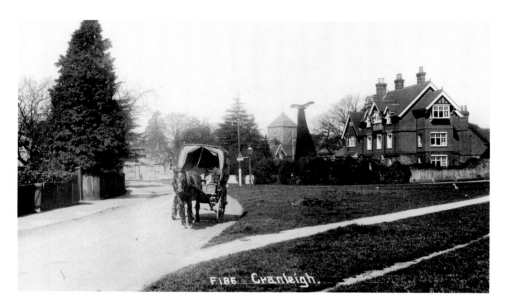

Luck's Green

Luck's Green stands at the eastern approach to the village and is the remnant of an earlier, much larger common. Encroachment over the years from buildings and the turnpike road has reduced its size to its present extent. The large house in the background known as Yew Tree House was built for Stephen Rowland with all the architectural features fashionable in the High Victorian period. The yew tree carved in the shape of a cockerel echoes the weather vane on the church tower. Mr Knight's carriers' van waits patiently in the road. The ancient yew no longer dominates the scene and a later ash tree now largely obscures the fine features of Yew Tree House.

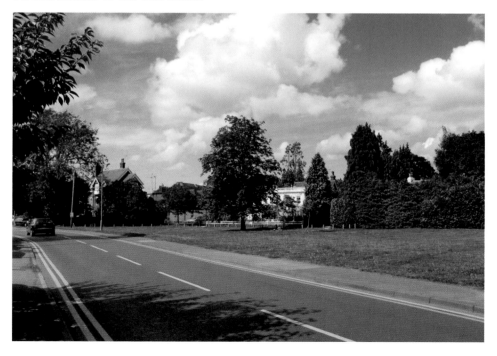

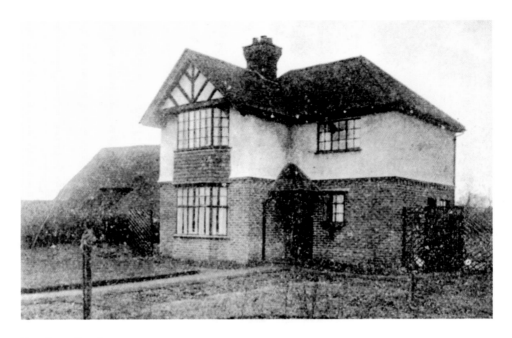

Horsham Road

Up until the 1930s the south side of Horsham Road remained largely undeveloped between Jubilee Cottages and Jenkins when the land was purchased and developed for building by A. B. Johnston as the Woodlands Estate. The builders for these properties were Auchterlonie & Reeves and a three-bedroom house could be purchased for as little as £700. Examples of their work can also be found in St Nicolas Avenue, typified by the use of pebbledash and token timber embellishments. The house is still recognisable today with its trademark decorative timbered gable. On the left is the roof of Jenkins barn where once Mr John Knight the carrier kept his cart and stabled his horse.

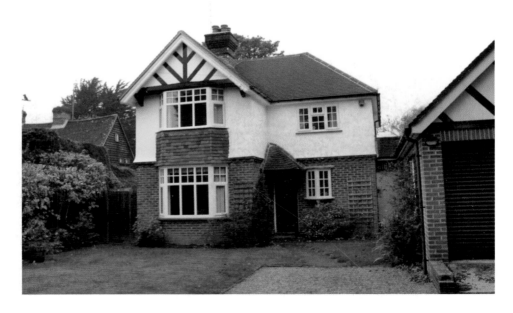

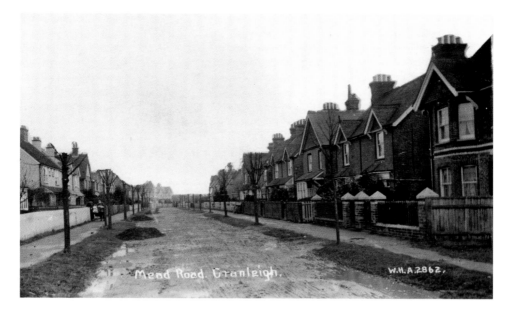

Mead Road

The cottages at the lower end of Mead Road date from a much earlier time than the remainder. The Cranleigh Waters proved a considerable physical barrier until Stephen Rowland built his bridges at the turn of the twentieth century and opened up the New Park estate for development. The houses seen here date from this time and were developed by the Land Company. They are fine examples of early semi-detached design characterised by the sloping roof of the bay continuing across the open porch.

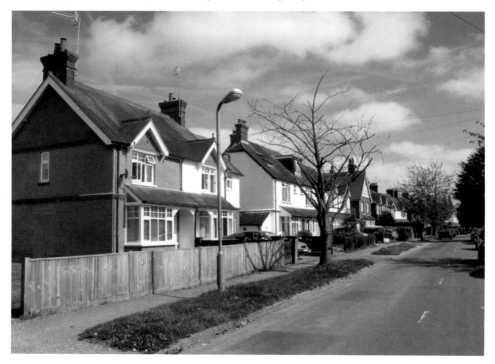

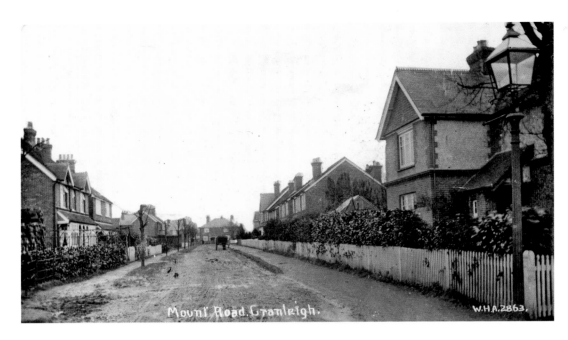

Mount Road

Mount Road links Horsham to Kings Road and is typical of the later build of the New Park estate when its development was taken over by the Land Company. When this picture was taken, around 1910, the road had not been surfaced and the trees were newly planted. A single cart can be seen in the distance. Today the scene cannot be duplicated due to parked cars and the trees have now matured.

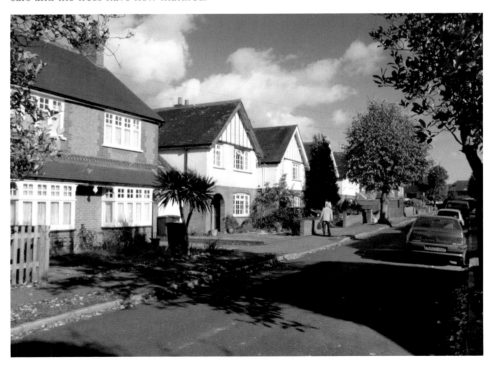

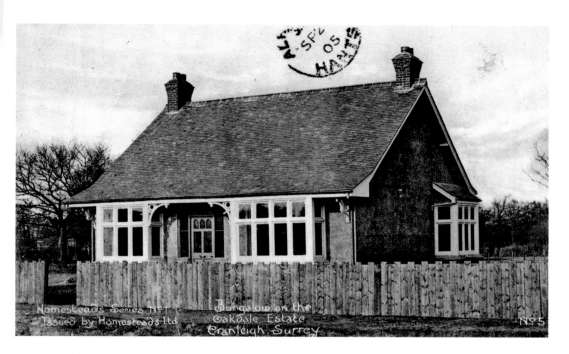

Oakdale Estates

Many of the houses in Avenue Road are of a larger individual design but others were built by Homesteads Ltd in what they referred to as the Oakdale estate. The trademark 'O' appears in the decorative carpentry of the houses built by them in the estate. The house known as Kuhling remains today albeit hidden behind a high hedge and overshadowed by a large fir tree.

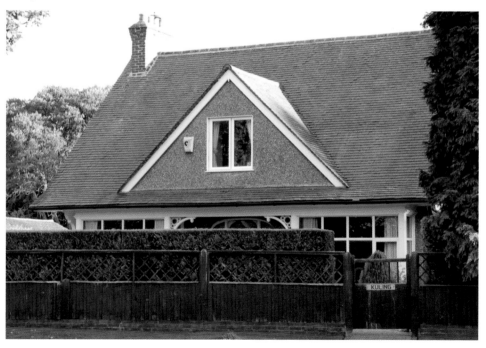

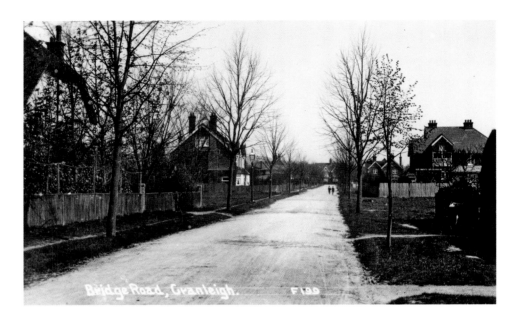

Bridge Road, Cranleigh. F199

Bridge Road

This view looking towards New Park Road exemplifies Stephen Rowland's vision of a tree-lined avenue with large detached houses standing in ample gardens. The grand house on the right with the balcony is Whinthorpe, with Hesketh House in the background. In the middle ground is Hardwycke, once a convent, and to the extreme left is Ramsbury, where Stephen Rowland lived in latter times until his death at the grand old age of ninety-nine years and six months.

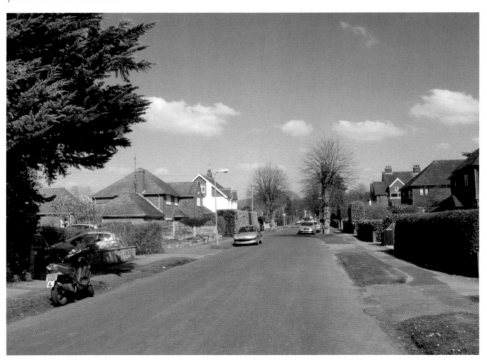

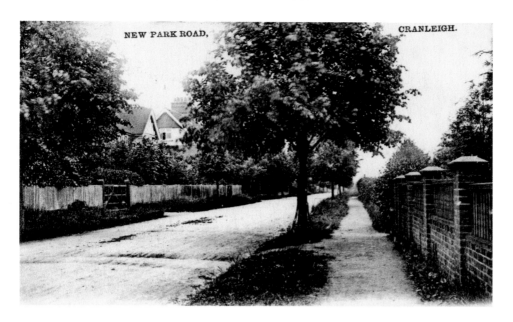

New Park Road

Oakhurst is the first of a group of fine houses in New Park Road. Built in 1897, it boasts an observation tower facing the church and a three-storey construction, typical of the High Victorian style. After the Second World War it became the home of author Arthur Calder-Marshall and his daughter Anna who later became an actress of film and television. When the company was set up each plot was sold subject to a house of a stipulated value being built on it. Some of these houses can be seen on the left of this picture and the scene remains largely unchanged today.

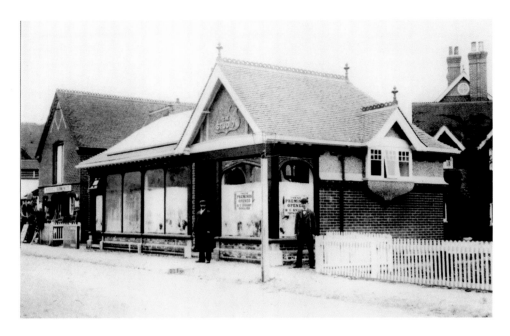

Knight's Studio

The Studio in Ewhurst Road was purpose-built in 1903 as a photographic studio for our first photographer Henry Upperton Knight. H. U. Knight Photographer is an imprimatur that appears on many portraits and postcards of the area. He was born in Upperton, near Petworth, and remained until 1909 when he appeared in British Columbia, Canada, and forged a new career in real estate. The old studio is now divided into two premises but The Studio name tablet remains.

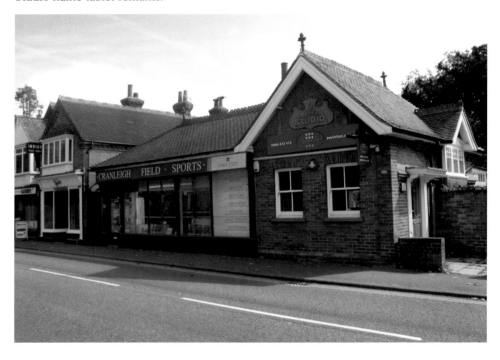

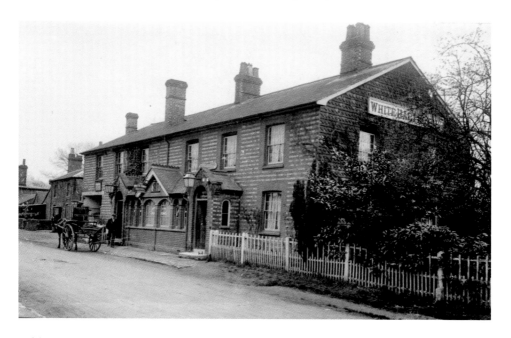

White Hart

The White Hart Inn opened in the 1860s when the first landlord was Phelp Gammon, an incomer from Oxfordshire. At first the inn had its own brewery, but this was later taken over by George Bruford's Cranleigh Steam Brewery, who continued to supply the pub until Savills took over. Around 1890 the premises became a hotel under the stewardship of George Wickham.

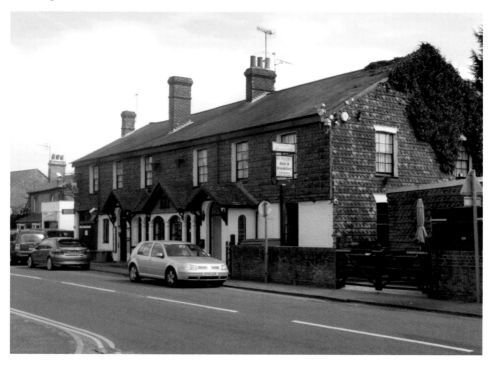

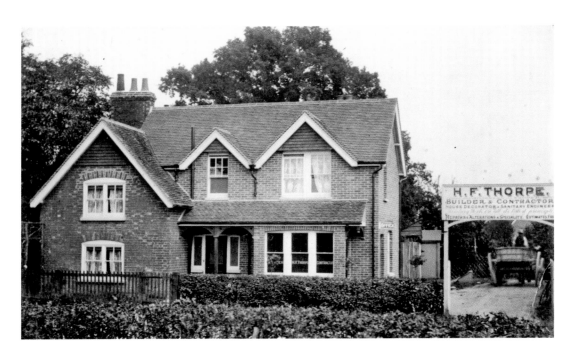

H. F. Thorpe

The building firm of H. F. Thorpe was responsible for many of the fine buildings in Cranleigh. Apart from building, contemporary advertisements show Thorpe's offering painting and decorating, plumbing, steam sawing, roads, drainage and undertaking. Later the site was taken over by Auchterlonie & Reeves who were responsible for building many of the houses in Horsham Road and St Nicolas Avenue.

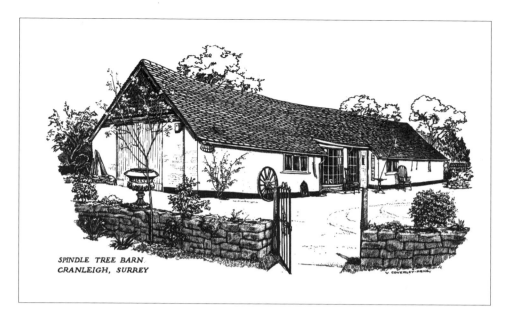

SPINDLE TREE BARN
CRANLEIGH, SURREY

Old Barn

The Old Barn is one of the properties that once faced Bedlow Lane. This area was subject to flooding and the old name of Bedlam Lane may be an indication of the chaos caused by disruption to traffic and overcrowding. The modern road was raised and straightened in the 1820s and the entrance to the barn reversed. Little is known about its early use but at one time it was known as Spindle Tree Barn, a possible reference to weaving. In contrast the traditional seventeenth-century building is now put to use by an organisation offering services for the twenty-first-century applications for the internet.

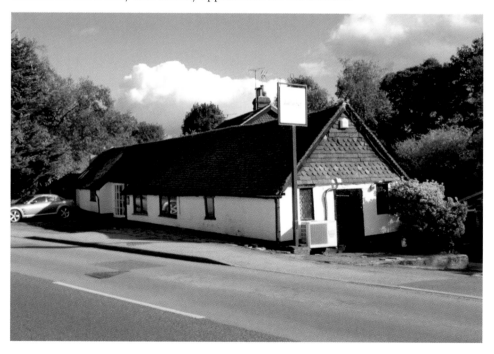

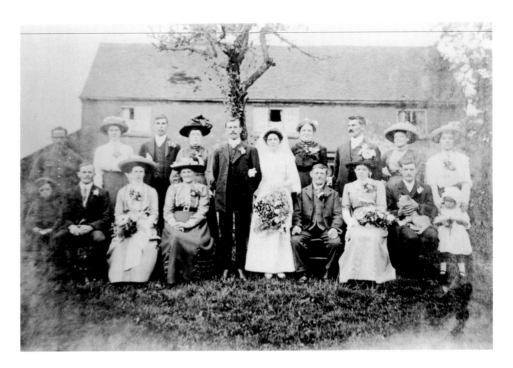

Park Hatch

The picture above shows the wedding of Albert Worsfold to Alice Hilda Parsons on 1 September 1913. The reception took place at Parkhouse Farm Cottage. The old cottage opened as the Little Park Hatch public house in the 1960s and has been extended over the years. It is difficult to relate the modern picture to the one 100 years earlier, but the apple tree is a common feature to both images.

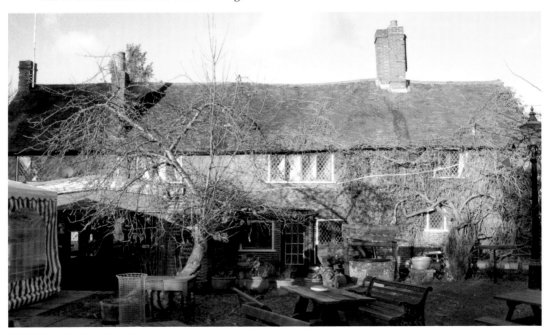

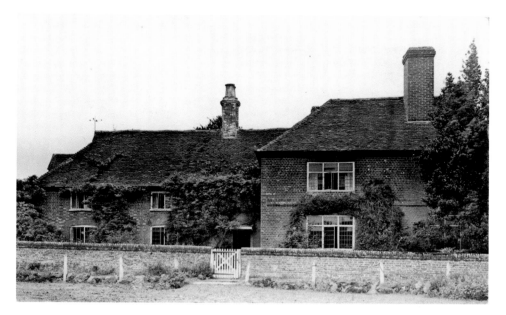

Barhatch

Barhatch is an ancient and important site situated on the route between the manor of Shere and the lord's estates in the Weald. It is known that large areas were used to provide deer hunting, and the name Barhatch suggests there was a gated entrance nearby. The medieval farmhouse is a substantial building originally of four bays, and dendrochronology has established a build date of 1429. For most of the eighteenth century the house was occupied by the Tickner family and a large cross-wing was added during this time. The premises also include a large threshing barn and circular depression in the ground, possibly used as a cock-fighting pit. Since 1985 the old farm fields have been adapted for use as a golf course.

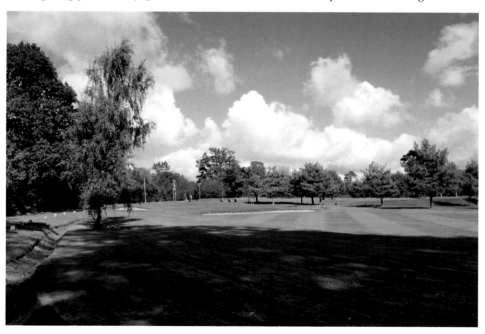

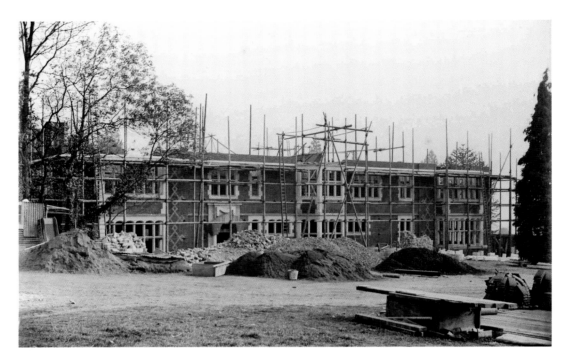

Wyphurst I

The present Wyphurst farmhouse bears little resemblance to its original form, having been enlarged on several occasions, most notably in 1907. Sir Charles Chadwyck Healey commissioned architect Reginald Blomfield to add a substantial wing in a Tudor style with diaper-patterned brickwork. The picture shows the work underway. Sir Charles served on the parish council and was a great beneficiary to the village. His son Gerald inherited the baronetcy on his father's death in 1919. He served in the Royal Navy Volunteer Reserve and joined the Royal Navy in the First World War. The family notably donated the land on which the village hall was built. Sir Gerald Chadwyck Healey can be seen in the inset in naval uniform.

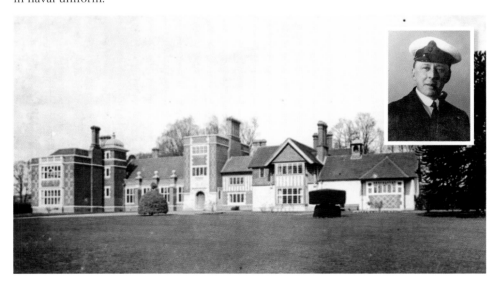

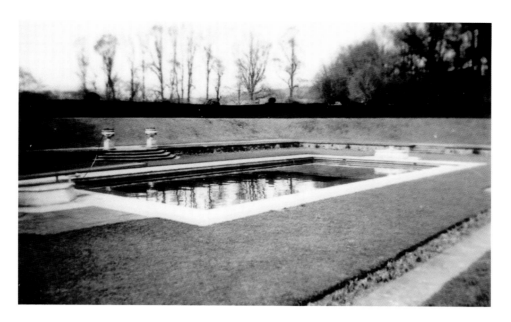

Wyphurst II

Facilities included a ballroom and an externally separate viewing platform or belvedere, with a western aspect overlooking the artificial lake formed by damming a stream in a narrow valley. During the Second World War the house was occupied by Canadian troops and, as an act of gratitude, they contributed to the building of a swimming pool in the grounds. The premises are now occupied by a school for children with learning difficulties. The picture shows the lodge of St Joseph's School.

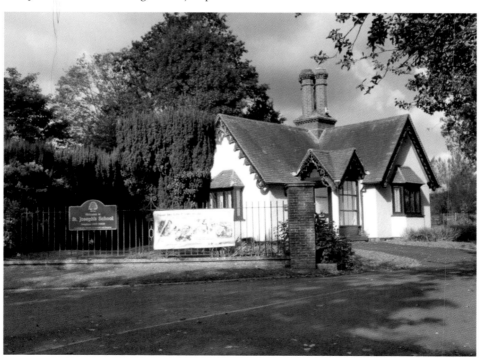

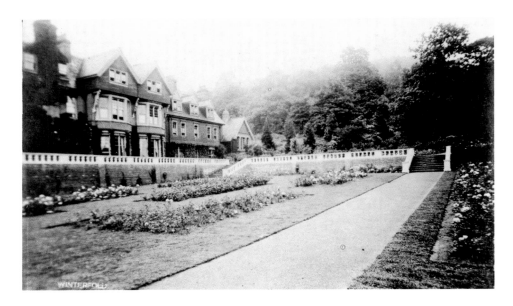

Winterfold

In 1887 one Richard Everard Webster, a prominent London barrister, settled on a parcel of land in the Hurtwood estate owned by the manor of Shere. Later he progressed to Lord Chief Justice and Viscount Alverstone, and was able to enlarge his estate by acquiring more acres from neighbouring landowners. The house was the first in the district to have its own electricity generating plant and became a self-contained community with servants living in their own estate cottages. During the Second World War the discrete location made it ideal as a reception college for recruits to the highly secretive Special Operations Executive. In 1963 it obtained a different notoriety when members of the Great Train Robbery were thought to be holed up there, but extensive police searches found nothing.

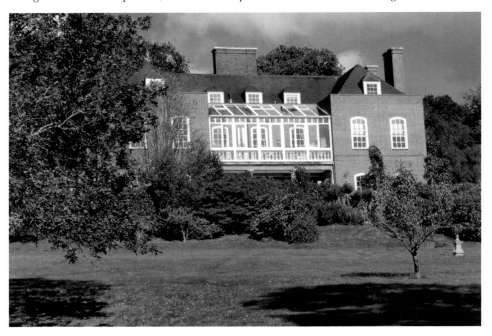

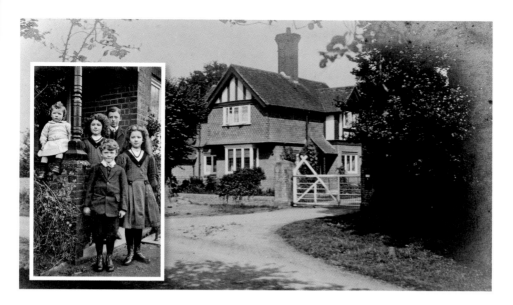

Alderbrook

With the advent of the railway Cranleigh came within reach of London dwellers seeking a weekend country refuge. Mr Pandelli Ralli, a Greek shipping magnate, settled on 270 acres of relatively inexpensive agricultural land in the lee of the Surrey Hills, with views overlooking the Weald. A country house, designed by Robert Norman Shaw, provided for all the needs of a country gentleman, including entrance lodge gates, access roads, a stable block and even a working farm. Like so many of our country houses it was taken over by the military during the war and suffered from neglect, so much so that new owners decided to demolish the old house and replace it with a more modest dwelling in keeping with the age of austerity. The lodge was built to oversee the entrance from Smithwood Common. In 1910 it was home to the Charles family. William Charles was farm bailiff at the time. Inset: The five Charles children outside the lodge. The eldest brother Jack was later killed in First World War.

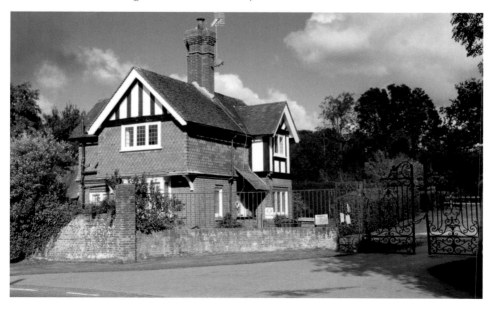

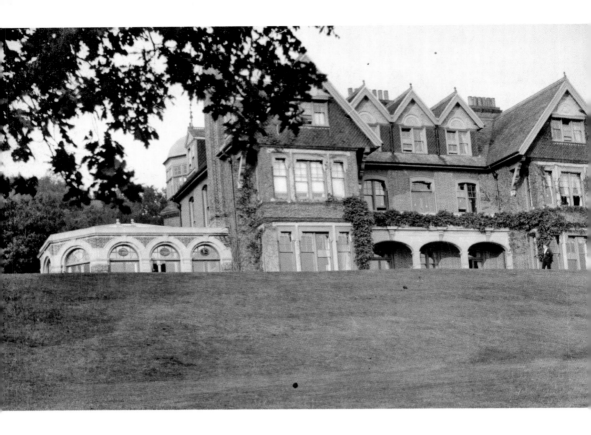

Acknowledgements

In compiling this book I am particularly indebted to those who have lent their family photographs and postcards for publication. I am particularly grateful to Roy Pobgee and the families of Roy Foster and Joy Attwell, who were only too pleased to pass on their personal collections in the hope that the images would be made available to a wider audience. Richard Greening gladly copied his carefully crafted watercolour of Chapel Place, giving a pleasant counterpoint to the glossy digital photographs of today. I have been encouraged by members of the Cranleigh History Society and I have been pleased to be able to draw on publications by previous authors, in particular those by Judie English and Christopher Budgen. The Surrey Postcard Club has been an invaluable source of material and information and I would particularly like to thank Nigel Balchin for generously allowing me to take copies from his extensive collection. The expertise passed on by members of the Domestic Buildings Research Group (Surrey) has enabled dating of some of the timber-framed buildings, and where exact dates have been given these have been determined through dendrochronolgy and published with the owner's permission. If I have failed to mention anyone in particular, this is as a result of my own failing and in no way diminishes the contribution they have made.